THE
ANTICHRIST
+ FRAGMENTS FROM
A SHATTERING MIND

T0027012

THE ANTICHRIST
+ FRAGMENTS FROM A SHATTERING MIND
Friedrich Nietzsche
ISBN 10: 0-9714578-5-9
ISBN 13: 978-0-9714578-5-0
Published 2007 by Solar Books
www.tearscorp.com
First published 2002 by Creation Books
www.creationbooks.com
Translated by Dr Domino Falls
Copyright ©Creation Books 2002
Introduction © Stephen Barber 2002
Foreword © Creation Books 1995
"Fragments"
translated by Otmar Lichtenwörther
Copyright © Creation Books 2002, 2007
All world rights reserved
Design: Whitelight
Lords of the Solar Church, volume 1:
Friedrich Nietzsche

INTRODUCTION
THE FRAGMENTS

On 3 January 1889, in the Piazza Carlo Alberto in the northern Italian city of Turin, Friedrich Nietzsche watched an old carthorse being frenziedly beaten by its driver; Nietzsche abruptly flung his arms around the horse's neck, weeping and protesting, before fainting into a syphilitic coma. When he re-emerged into consciousness, the philosopher had become irretrievably insane; although he lived for another eleven years, until 25 August 1900, his wrote almost nothing further and immersed himself in a profound silence, in his sister's house, as he awaited death.

This volume collects Nietzsche's final fragments from the period leading up to that collapse; the last words in the volume emerge from the final days before Nietzsche's desperate urban intervention. This is the first ever English-language publication (after their German-language publication in 1996) of Nietzsche's ultimate pronouncements on power and totalitarian imperatives, on sensation and ecstasy, on the summary repudiation of the Christian religion, on the figure of the Antichrist, and on the active nihilism which Nietzsche viewed as seminal and essential at the moment of the onset of the philosophical and political obsessions which would turn the twentieth century into a scorched-earth terrain of atrocity, with the twin gods of communism and fascism commanding the near-eradication of the tainted human species.

Nietzsche's use of the fragment anticipates that of many of the figures who most directly probed the intimate relationship between language, ecstasy and madness in the

first half of the twentieth century: prominent among them, Georges Bataille and Antonin Artaud in France, Franz Kafka and Robert Walser in the German-speaking world. The fragment, for Nietzsche at this extreme point in his work, is the matter which implosively compacts an otherwise inarticulable content and directly unleashes it for the reader (although that reader, through the hesitancies and suppressions of editorial policies, needed to wait over a century before being subjected to its sensorial and linguistic charge). The fragment had been a pre-eminent means of expression for the German Romantic poets, formulated to articulate a consciousness in disarray at the mass stimuli of urban or natural life; but in Nietzsche's work, the fragment is transformed into a weapon of attack and repudiation rather than a means for the surrendering of consciousness. Nietzsche's fragments, with their intensive internal conflict, form a zone of corporeal and sensory intensification which magnifies his preoccupations to almost infinite dimensions: the imposition of Nietzsche's will nullifies every religious system, together with all conceptions of human stability and control, in order to institute a limitless imposition of self-divinifying, insurgent power.

The reader's sensory experience of Nietzsche's final fragments is as testing and unsettling as Nietzsche's own mental condition at the moment of their composition. The process of reading such evocations of power is a precarious and even vulnerable one, in many ways. The French philosopher Gilles Deleuze – whose own collaborations with Félix Guattari constitute a vast, fragmentary incorporation of the ultimately flux-driven human consciousness at the end of its political tether – often argued that, in his exacting final work, Nietzsche philosophically sodomizes his reader: 'He gets up to all kinds of things behind your back. He gives you a perverse taste – certainly something neither Marx nor Freud ever gave anyone – for saying simple things in your

own way, in affects, intensities, experiences, experiments.'[1] The psychoanalytical philosopher Slavoj Zizek's combative response to this position is that Deleuze himself strategically and systematically philosophically sodomized Nietzsche, and Zizek's own counter-theoretical, meta-corporeal strategy is to suggest that the reader – inevitably a male reader, in Zizek's Lacanian cosmogony – needs to reposition himself behind Deleuze, effectively sodomizing Deleuze at the same time that he sodomizes Nietzsche, who in turn is simultaneously sodomizing the reader[2] – so that, finally, the reader is able determinedly to collapse that deviant chain of signification and become engaged in a creative and active process of self-sodomy: an ultimate state of jouissant and necessarily violent liberation.

In his study of the denigration of vision in twentieth-century thought, the American political philosopher Martin Jay notes that: 'Nietzsche's critique extended to the putatively disinterested purity of even the partial perspectivalist gaze, which was assumed by positivists and their aesthetic correlates, the Impressionists and Naturalists. Himself plagued by failing eyesight from the age of twelve on, Nietzsche knew of the pitfalls of relying on visual experience alone... He insisted that every viewpoint was always value-laden, never detached. Vision was thus as much projective as receptive, as much active as passive.'[3] It is this caustic assault on the obstructive 'blindness' of vision that is most intensively marked in Nietzsche's final fragments. His own philosophical imperatives are carried sensorially, with an ultimate collapsing of representation which allows the reader to enter a state of radical visual and linguistic abbreviation – whatever is sought in these fragments can be instantly located, de- and re-visualized in a readerly act of nihilistic self-will. From that point onwards, the fragment forms an endless source of propulsive incitation, constantly refigured with each act of reading.

The Antichrist, ultimately, can only articulate himself through the fragment (in direct repudiation of the biblical, genealogically and temporally amassed character of Christianity and its antecedents): the fragment is the point at which language is unhinged from its imposed strata of signification – necessarily constrictive and deadening, for Nietzsche – in order to flare, however briefly and catastrophically, in its own autonomous direction. No longer language, no longer vision or image (though still conceivably an active work of art), Nietzsche's final fragment is the terminal zone at which every obsession and compulsion becomes immediately expressed, in a sensorial rush, before everything (and everyone: Nietzsche above all) precipitately combusts in the white-hot infinity of insanity, disintegration and silence.

The critical demands of Nietzsche's work have been misunderstood more than that of any other writer of his stature. Jean Genet read the entirety of Nietzsche's then-published work on the island of Corfu in 1961 and commented in a letter from 1963: 'The idea that to think of possessing thousands of acres and castles, to imagine that that is to live like a superman – that's simply imbecilic. Nietzsche demanded a more rigorous morality for his superman.'[4] The publication of Nietzsche's final fragments now salutarily provides their reader with an ultimate rigour and an ultimate challenge.

–Stephen Barber

1. Gilles Deleuze, Negotiations, Columbia University Press, New York, 1995, p.6.
2. Slavoj Zizek, lecture at the Kunsthalle am Karlsplatz, Vienna, 9 November 2002.
3. Martin Jay, Downcast Eyes, University of California Press, Berkeley, 1994, pp.190–191.
4. Jean Genet, unpublished manuscript letter from 1963, viewed at the IMEC archives, Paris, 2002.

DEAD GOD

A cold wind blows across empty space. Dark matter obscures the sun. Wreckage of exploded stars drifts in the void, the ruins of a solar system, burned-out at 3,000K, radiating annihilation in all directions. A single beam of light, cutting through the gloom, frames the silhouetted body of a dead God, stretching cruciform across the galaxy; face taut with pain, spikes wounding wrist and ankle – borne continually upwards towards the vault of the Heavens, where divinities go to die, but all the while drawn down into the abyss below. Lead weights lashed to the base and the vertical struts of the scaffold plumb the deep. The crucified hangs on a counterweight, falling far into emptiness. While He thirsts for eternal order, purity, light, redemption, the counterweight pulls all that is holy back down towards the distant memory of something darker: the general economy of base matter, meat, blood, and blind impulse from which it was emitted – a mistake dropping off the end of a human production line. A human product which suddenly reaches the scrap heap of worthless ideas in an unplanned obsolescence. Dead God. Aborted divinity. Enemy of multitude stars. Stone baby of the macrocosm. Evacuated cyclopean eye of the celestial sphere.

Shadows black-out the horizon in a single stroke. Morbid expectations of apocalypse. Ledgers kept in minute detail plot the geometries and timescales of the end of the world. Vertigo and nausea proliferate, requiring that the stomach expands to accommodate ever greater magnitudes of sickness. Pulsing chaos tears apart the fabric of the universe. The last days fade out along the line of a fuse....

So what was it that ruined this passional gothic theatre of obliteration? What was it that robbed us of the comic spectacle of all the sinners falling to their knees, hands outstretched in terror, before all being wiped-out in some final holocaust of divine judgement? It was this: *something like divine order without God*. God's shadow, smeared on the walls of his burial cave. Transcendental authority.

Deicide undertaken, and the old Logos of the universe a bloodless corpse, hacked into pieces by a multitude of blades; business confidence is not shaken at all along a street of graves, churches, memorials, tombs. In fact, something of an upturn is taking place. No-one is troubled by the sound of gravediggers echoing across the marketplace at daybreak. No-one detects the faint smell of death which hangs in the mist. And this is why: by itself, the death of God is not a particularly significant event – we have no interest in repeatedly exhuming the sacred corpse in order to cut it down again, however gratifying the feeling of revenge might be.

We mistrust the death of this God. And if our decadent fantasies should once again turn towards this theological apocalypse which failed to complete itself, and trickled away into inexistence, are we not, then, merely longing for His second coming? Do we have to condemn ourselves to eternal nostalgia for the intransitory?

To us, the death of God is a cipher; a slash of shorthand marking the absence of any stable centre to the universe – the desolation of any spike on which the celestial sphere rotates, impaled, like a worn-out gyroscope running down to a halt. And the celestial sphere itself.

After all, God was one of our more benign errors. We can only speculate as to how comforting the idea of Him can

have been for childlike monotheistic savages – people who needed the preternatural apparition of some old patriarch, stroking his long, grey beard somewhere up in the stratosphere, in order to drift out into exhausted hibernation: who needed someone who added purpose to life, encrypting an originary guilt-trip upon an organism coming into being by projecting its utter self-loathing back at itself from a geographically infinite, ethereal domain beyond the earth.

One huge Copernican revolution later (that of Kant), this guilty catholic promise of no future energizes the economy as protestant liberalism translates the realm of debt onto the commodity form and its potentially endless circulation. An anthropomorphized universe grinds into slow revolutions around Man, humanity, human laws; reason which dictates its concepts, axioms, numbers, bodies, planes, causes, and effects to the universe. Order is maintained, without any interruption from God, by means of pain machines, contracts, tribunals, legal systems, communities, cultures, states – subjects and authors: beings, all *a priori* legally responsible for their own actions – teleologically judging themselves to be the ultimate end of evolution. The ultimate man. The last man.

This is why the death of God is so insignificant. Humanism's project – to set the value of everything in place by processing it all through this secular digestive system – looms out of the chaotic manifold of deep space as an infinitely more functional machine for the maintenance of cosmic order than feeble theology ever was. It seals itself off from the future where it falls down ruined. Maybe this is the last and greatest revenge of religious souls stripped of their divinity. For what does it make of anyone seeking to think beyond these structures? Illegitimate, insane, illegal, inhuman, impossible. A dead fanatic – something that squanders its

life howling mad curses in semi-silenced desperation.

Beyond the shorelines of this temperate cultural belt, there is only the jungle, where animal eyes glower, yellow, with hunger and malice; the scorched, white expanses of the desert, or the metallic water tables of the steppes and the tundra; the violent turbulence of the ocean, churning storm fronts, and hurricanes. Everything is at sea, the gaze perhaps turning back towards the safety of all that lies behind. We turn to the south, where we will melt in futuristic heat.

–Stephen Metcalf

THE
ANTICHRIST
+ FRAGMENTS FROM
A SHATTERING MIND

FRIEDRICH NIETZSCHE

PREFACE

This book belongs to the chosen few. Perhaps not one of them is yet born. It is possible that they may be among those who understand my "Zarathustra": how *could* I confound myself with those for whom there are ears today? – First, the day after tomorrow must belong to me. Some men are born posthumously.

The conditions under which any one understands me, and *necessarily* understands me – I know them all too well. Even to endure my rigour, my passion, one must carry intellectual integrity to the verge of steel resilience. One must be accustomed to living on mountain tops – and to looking down upon the wretched chatter of politics and nationalism as beneath contempt. One must have become indifferent; must never ask of the truth whether it brings power or death... One must have a hunger, born of strength, for questions that no one has the courage for; the courage for the *forbidden*; sympathy for the labyrinth. The experience of seven solitudes. New ears for new music. New eyes for what is most distant. A new conscience for truths that have hitherto remained unvoiced. *And* the will to power in the grand manner – to hold together strength, fervour... Reverence for oneself; love of oneself; an absolute freedom of self

Very well, then! These alone are my readers, my true readers, my preordained readers: of what value are the rest? – The rest are merely human cattle. – One must make oneself superior to humanity, in power, in beauty of soul, – in utter contempt.

–FRIEDRICH NIETZSCHE

1.

– Let us look each other in the eye. We are Hyperboreans – we know well enough how remote our dwelling-place is. "Neither by land nor by sea will you find the road to the Hyperboreans": even Pindar, in his day, knew that much about us. Beyond the North, beyond the ice, beyond death – *our* life, *our* happiness... We have discovered happiness; we know the way; we got our knowledge of it from thousands of years crouching in the labyrinth. Who *else* has found it? – modern man? – "I don't know either the way out or the way in; I am everything which doesn't know which way to turn" – so sighs the man of today... *This* is the sort of modernity that made us ill, – we grew sick on lazy peace, cowardly compromise, the whole virtuous filth of the modern Yes and No. This tolerance and *largeur* of the heart that "forgives" everything because it "understands" everything is a wind of pestilence to us. Better to live amid the ice wastes than among modern virtues and other such south-winds!... We were brave enough; we spared neither ourselves nor others; but we were a long time deciding *where* to direct our courage. We grew dismal; they called us fatalists. *Our* fate – was the vastness, the tension, the damming up of our powers. We thirsted for lightning and bloody action; we kept as far away as possible from the happiness of the weakling, from "resignation"... There was thunder in our air; nature, as we embodied it, grew black – *for we had not yet found the true way*. The formula of our happiness: a Yes, a No, a straight line, an *objective*...

2.

What is good? – Whatever heightens the feeling of power, the will to power, power itself, in man.

What is evil? – Whatever springs from weakness.

What is happiness? – The feeling that power *increases* - that resistance is overcome.

Not complacency, but more power; *not* peace at any price, but total war; *not* virtue, but ruthless efficiency (virtue in the Renaissance sense, *virtù*, virtue free of moral coding).

The weak and the deformed shall perish: first principle of *our* philosophy. And we should aid their demise.

What is more harmful than any vice? – Sympathy for the crippled and the weak – *Christianity*...

<div align="center">3.</div>

The problem that I present here is not what should replace mankind in the order of living creatures (man is a *terminal* being –): but what type of man must be bred, must be willed, as being the most valuable, the most worthy of life, the most certain keeper of the future.

This more valuable type has existed often enough in the past: but always as a lucky accident, as an exception, never as deliberately *willed*. He has often been the most feared; he has been the ultimate figure of terror; – and out of that terror an opposite type has been willed, cultivated and attained: the domestic animal, the herd animal, the sick and lowly brute-man – the Christian...

<div align="center">4.</div>

Mankind surely does *not* represent an evolution toward a better or stronger or higher level, as progress is understood today. "Progress" is merely a modern idea,

which is to say, a false idea. The European of today, in his essential value, falls far below the European of the Renaissance; the process of evolution does *not* necessarily mean elevation, advancement, or strength-ening.

True, it can succeed in isolated and individual cases in various parts of the earth and in widely different cultures, and in these cases a *higher type* certainly manifests itself; a breed which, compared to mankind in general, appears as a sort of superman. Such chance strokes of great success have always been possible, and will, perhaps, always remain possible. Even whole races, tribes, and nations may occasionally represent such *lucky manifestations*.

5.

We should not dress up or embellish Christianity: it has waged a *war to the death* against this higher type of man, it has excommunicated all the deepest instincts of this type, it has distilled its concept of evil, of the *Evil One* himself, out of these instincts – the strong human as the arch criminal, the "outcast among men". Christianity has taken the side of all the weak, the lowly, the deformed; it has made an ideal out of *opposition* to all the self-preserving instincts of strong life; it has corrupted even the faculties of those who are intellectually most vigorous, by representing the highest intellects as sinful, as mendacious, as harbingers of *temptation*. The most deplorable example: the corruption of Pascal, who believed that his intellect had been destroyed by original sin, whereas it was actually destroyed by Christianity! –

6.

It is a painful and tragic spectacle that rises up before me: I have drawn back the curtain from the *depravity* of man.

This word, in my mouth, is at least free from one suspicion: that it involves any moral accusation against humanity. It is used – and I wish to emphasize the fact again – without any moral posturing: and this is so far true that the depravity I speak of is most apparent to me precisely in those squalid quarters where there has been most conscious aspiration to "virtue" and "godliness". As you may surmise, I speak of depravity in the sense of *decadence*: my assertion is that all the values on which mankind now bases its highest aspirations are *decadence-values*.

I call an animal, a species, an individual depraved when it loses its instincts, when it chooses, when it *prefers*, what is ultimately harmful to it. A history of the higher feelings", the "ideals of humanity" – and it is possible that I may have to narrate it – would almost explain *why* man is so degenerate. Life itself appears to me as an instinct for growth, for survival, for the accumulation of forces, for *power*: whenever the will to power fails there is decline. My contention is that all the highest values of humanity have been *voided* of this will – that the values of decadence, of *nihilism*, now fester under the holiest names.

7.

Christianity is known as the religion of *pity*. – Pity stands in opposition to all the vital passions that augment the energy of the feeling of life: it is a depressant. A man loses power when he pities. Through pity that ebbing of strength which suffering initiates is multiplied a thousandfold. Suffering is made contagious by pity; sometimes it may lead to a total sacrifice of life and life-energy – a loss out of all proportion to the magnitude of its cause (– the case of the death of the Nazarene). This

is the first aspect of it; there is, however, a still more important one. If one evaluates pity by the gravity of the reactions it causes, its nature as a menace to life appears in a much clearer light. Pity retards the whole law of evolution, which is the law of *natural selection*. It preserves whatever is ripe for destruction; it fights on the side of those disinherited and condemned by life; by maintaining life in so many of the crippled of all kinds, it gives life itself a gloomy and dubious aspect. Mankind has dared to call pity a virtue (– in every *superior* moral system it appears as a weakness –); moreover, it has been called *the* main virtue, the source and foundation of all other virtues – but let us always remember that this was from the viewpoint of a philosophy that was nihilistic, and upon whose shield *denial of life* was inscribed. Schopenhauer was right in this: that by pity life is denied, and made *more worthy of denial* – pity is the *building-block* of nihilism. Let me repeat: this depressing and contagious instinct stands against all those instincts which work in favour of the preservation and enhancement of life: as *protector* of the miserable, it is a prime agent in the replication of decadence – pity leads to *total extinction* Of course, one doesn't say "extinction": one says "the other world", or "God", or "the true life", or Nirvana, salvation, holiness This innocent rhetoric, from the realm of religio-ethical drivel, appears *much less innocent* when one reflects upon the impulse that it conceals beneath sublime words: the impulse *to destroy life*. Schopenhauer was hostile to life: that is why pity appeared to him as a virtue... Aristotle, as everyone knows, saw in pity a morbid and dangerous state of mind, the only remedy for which was a regular purgative: he regarded tragedy as that purgative. The instinct for life should prompt us to seek some means of annihilating any such pathological and dangerous accumulation of pity as that which appears in Schopenhauer's case (and also,

sadly, in that of our whole literary and artistic *decadence*, from St. Petersburg to Paris, from Tolstoi to Wagner), so that it may burst and be discharged like pus... Nothing is more unhealthy, amid all our unhealthy modernity, than Christian pity. To be surgeons *here*, to be merciless *here*, to wield the knife *here* – all this is *our* destiny, all this is *our* sort of humanity, by this sign *we* are philosophers, we Hyperboreans! –

<div align="center">8.</div>

It is necessary to say exactly *whom* we regard as our antagonists: theologians and all who have any theological blood in their veins – this is our whole philosophy... One must have faced that menace at close hand or, better still, one must have had experience of it directly and almost perished by it, to realize that it is not to be taken lightly (– the alleged free-thinking of our naturalists and physiologists seems to me to be an absurd *joke* – they have no passion about such things; they have not *suffered* –). This poison extends a great deal further than most people think: I have exposed the arrogant instinct of the theologian among all who regard themselves as "idealists" – among all those who, by virtue of a higher origin, claim a right to rise above reality, and to regard it askance... The idealist, like the priest, bears all sorts of lofty concepts in his hand (– and not only in his hand!); he launches them with sly, benevolent contempt against "understanding", "the senses", "honour", "good living", "science"; he sees such things as *beneath* him, as pernicious and seductive forces, above which "the soul" soars as a pure self-contained entity – as if humility, chastity, poverty, in a word, *holiness*, had not already done much more damage to life than any imaginable horrors and vices... The concept of pure soul is a pure lie... So long as the priest, that *habitual* denier, liar and

poisoner of life, is accepted as a higher variety of man, there can be no answer to the question: What *is* truth? Truth has already been inverted when the deliberate advocate of negation and nothingness is mistaken for its representative.

<div align="center">9.</div>

I declare war upon this theological instinct war: I find the traces of it everywhere. Whoever has theological blood in his veins is deceitful and dishonourable in all things. The pathetic creature that evolves out of this condition is called *faith*: in other words, closing one's eyes upon one's self once and for all, to avoid suffering the sight of an incurable falsehood. People erect a concept of morality, of virtue, of holiness upon this false perspective on all things; they base good conscience upon defective vision; they argue that no other sort of vision has value any more, once they have made their own views sacrosanct with the names of "God", "salvation", and "eternity". I have unearthed this theological instinct everywhere: it is the most widespread, singularly *subterranean* form of falsehood to be found on earth. Whatever a theologian regards as true *must* be false: there stands a criterion of truth. His most profound instinct of self-preservation forbids truth ever receiving esteem in any way, or even being admitted. Wherever the influence of theologians is felt there is a *transvaluation* of values, and the concepts "true" and "false" are forced to reverse places: whatever is most damaging to life is called "true", and whatever exalts life, intensifies it, affirms it, justifies it and makes it triumphant is called "false"... When theologians, working by way of the "consciences" of princes (*or* of peoples –), stretch out their claws for power, there is never any doubt as to the fundamental issue: the will to the end, the *nihilistic* will craves power...

10.

Among Germans it is immediately understood when I say that theological blood is the ruin of philosophy. The Protestant pastor is the grandfather of German philosophy; Protestantism itself is its original sin. Definition of Protestantism: the lopsided paralysis of Christianity – *and* of reason One need only utter the words "Tübingen School" to get an understanding of what German philosophy is fundamentally – a very *cunning* form of theology... The Swabians are the best liars in Germany; they lie innocently... Why such rejoicing over the appearance of *Kant* that rippled through the academic world of Germany, three-quarters of which is made up of the sons of preachers and teachers – why that German conviction, still echoing today, that with Kant came a change for the *better*? The theological instinct of German scholars made them see clearly just *what* had become possible again... A secret path leading to the old ideal stood agape; the concept of the "true world", the concept of morality as the *essence* of the world (– the two most vicious errors that ever existed!), were once more, thanks to a subtle and sly scepticism, if not actually demonstrable, then at least no longer *refutable*... Reason, the *prerogative* of reason, does not extend so far... Out of reality there had been made a "facade"; an absolutely *fabricated* world, that of being, had been turned into reality... The success of Kant is merely a theological success; he was, like Luther and Leibnitz, just one more constraint upon German integrity, which was already far from steady. –

11.

A word now against Kant as a *moralist*. A virtue must be *our* invention; our most personal need and defence. In

every other case it is merely a danger. That which does not belong to our life *threatens* it; a virtue which has its roots in mere respect for the concept of "virtue", as Kant would have it, is dangerous. "Virtue", "duty", "good for its own sake", impersonal or universal – these are all phantoms, and in them one finds only an expression of decay, the last exhaustion of life, the Chinese spirit of Königsberg. The absolute opposite is demanded by the most profound laws of self-preservation and of growth: that every man find *his own* virtue, *his own* unflinching imperative. A nation shatters when it confuses *its own* duty with the *general concept* of duty. Nothing wreaks a more complete and profound ruination than every "impersonal" duty, every sacrifice before the Moloch of abstraction. – To think that no one has thought of Kant's categorical imperative as *mortally dangerous*! ...The theological instinct alone took it under its protection! – An action compelled by the life-instinct proves that it is a *right* action by the amount of pleasure that accompanies it: and yet that nihilist, with his putrid bowels of Christian dogma, regarded pleasure as an *objection*... What destroys a man more quickly than to work, think and feel without inner compulsion, without deep personal desire, without *joy* – as a mere automaton of duty? That is the recipe for decadence, even for idiocy... Kant became an idiot. – And such a man was the contemporary of Goethe! This poisonous spider passed for the *German* philosopher – still passes today! I forbid myself to say what I think of the Germans Did Kant not see in the French Revolution the transformation of the state from the inorganic form to the *organic*? Did he not ask himself if there was a single event that could be explained save by a moral predisposition in man, so that with it, "the tendency of mankind toward the good" could be *proved*, once and for all time? Kant's answer: "That is revolution." Instinct at fault in everything and anything, instinct as a

revolt *against nature*, German *decadence* as a philosophy –
that is Kant!

12.

I exclude a few sceptics, the decent types in the history of
philosophy: but the rest haven't the slightest concept of
intellectual integrity. They behave like women, all these
great visionaries and prodigies – they regard "beautiful
feelings" as arguments, the "heaving breast" as the
bellows of divinity, conviction as the *criterion* of truth.
Finally, with "German" innocence, Kant tried to give a
scientific slant to this form of corruption, this utter lack
of intellectual conscience, by calling it "practical reason":
he deliberately invented a reason for use on occasions
when it was desirable not to trouble with reason –
namely, when morality, when the sublime command
"thou shalt", makes itself heard. If one considers the fact
that, among all nations, the philosopher is no more than
an evolutionary sidestep from the old type of priest, then
this inheritance from the priest, this *fraud upon self*, ceases
to be surprising. When a man thinks he has a divine
mission, for example to improve, to save or to liberate
mankind – when a man feels the divine spark in his heart
and believes that he is the mouthpiece of a preternatural
imperative – when such a mission inflames him, it seems
only natural that he should stand beyond all merely
reasonable values. He feels that he is *himself* sanctified by
this mission, that he is *himself* a prototype of a higher
order!... What does a priest care about *philosophy*! He
stands far above it! – And hitherto the priest has *ruled*! –
He has *determined* the very meaning of "true" and
"untrue"!...

13.

Let us not underestimate this: that we ourselves, we free spirits, are already a "transvaluation of all values", a declaration of war and victory *incarnate* against all the old concepts of "true" and "untrue". The most valuable insights are the last to be attained; but the most valuable of all are those which determine *methods*. *All* the methods, *all* the prerequisites of our modern scientific spirit, were the targets of the uttermost contempt for thousands of years; if a man embraced them he was excluded from the society of "decent" people – he was considered "an enemy of God", a despiser of truth, a man "possessed". As a man of science, he belonged to the Chandala... We have had the whole pathetic stupidity of mankind against us – its notion of what the truth *ought* to be, of what the service of the truth *ought* to be – its every "thou shalt" was directed against us... Our objectives, our methods, our quiet, cautious, distrustful manner – all appeared to mankind as absolutely unworthy and contemptible. – Looking back, one might reasonably ask oneself if it was not actually an *aesthetic* sense that blinded men for so long: what they demanded of the truth was a *picturesque* effect, and of the learned, a powerful impression on their senses. It was our *modesty* that offended their taste the longest... How well they divined that fact, those turkey-cocks of God!

14.

We have learned better. We have become more modest in every respect. We no longer trace our concept of man from the "spirit", from the "god-head"; we have placed him back down among the beasts. We regard him as the strongest of the beasts because he is the most cunning; his spirituality is one of the results of this. On the other

hand, we guard ourselves against a vanity which would express itself even here: the vain conceit that man is the great secret objective in the process of animal evolution. He is, in truth, anything but the crown of creation: beside him stand many other animals, all at similar stages of development... And even when we say that we assert too much, for man, relatively speaking, is the most flawed and sickliest of all the animals, and he has strayed the most dangerously from his instincts – though for all that, to be sure, he remains the most *interesting*! – As regards the lower animals, it was Descartes who first had the truly admirable daring to describe them as *machines*; the whole of our science of physiology is directed toward proving the truth of this doctrine. Moreover, it is illogical to set man apart from this, as Descartes did: what we know of man today is defined precisely by the extent to which we have regarded him, too, as a machine. Formerly we attributed to man, as his legacy from some higher order of beings, what was called "free will"; today we have stripped even this will from him, for the term no longer describes anything that we can understand as a faculty. The old word "will" now connotes only a sort of result, an individual reaction, that follows inevitably from a series of partly contradictory and partly harmonious stimuli – the will no longer "acts", or "moves" anything. Formerly it was thought that man's consciousness, his "spirit", offered evidence of his high origin, his divinity. To become *perfect*, he was advised, tortoise-like, to draw his senses in, to have no traffic with earthly things, to discard his mortal shell – then only the important part of him, the "pure spirit", would remain. Here again we have thought better: to us consciousness, or "the spirit", appears as a symptom of the relative imperfection of the organism, as an experiment, a groping, a fumbling, an affliction which burns up nervous energy unnecessarily – we deny that anything can be done perfectly so long as it

is done consciously. The "pure spirit" is pure stupidity:
take away the nervous system and the senses, the
so-called "mortal shell", and the rest is *miscalculation* –
that is all!...

15.

Under Christianity neither morality nor religion ha any
point of contact with reality. It offers purely imaginary
causes ("God", "soul", "ego", "spirit," "free will" – or even
"unfree will"), and purely imaginary effects ("sin",
"salvation", "grace", "punishment", "forgiveness of
sins"). Intercourse between imaginary *beings* ("God",
"spirits", "souls"); an imaginary *natural* science
(anthropocentric; a total denial of the concept of natural
causes); an imaginary *psychology* (mis-understandings of
self, misinterpretations of pleasant or unpleasant general
feelings – for example, of the condition of the *nervus
sympathicus* with the aid of the sign-language of
religio-ethical drivel -, "repentance", "pangs of
conscience", "temptation by the Devil", "the presence of
God"); an imaginary *teleology* (the "kingdom of God",
"the last judgment", "eternal life"). This purely fictitious
world, much to its disadvantage, is to be distinguished
from the world of dreams, by the fact that the latter at
least *reflects* reality, whereas the former falsifies it,
devalues it and denies it. Once the concept of "nature"
had been ranged in opposition to the concept of "God",
the word "natural" necessarily took on the meaning of
"abominable" – the whole of that fictitious world has its
sources in *hatred* of the natural (– reality! –), and is no
more than an expression of a profound discontent in the
presence of reality... *This explains everything.* Who alone
has any reason for *lying his way out* of reality? The man
who suffers under it. But to suffer from reality one must
be in a *flawed* reality... The preponderance of pain over

pleasure is the *cause* of this fictitious morality and religion: but such a preponderance also supplies the *formula* for *decadence*...

16.

Critical scrutiny of the *Christian concept of God* leads inevitably to the same conclusion. – A nation that still believes in itself holds fast to its own God. In him it venerates the conditions which enable it to survive, its virtues – it projects its joy in itself, its feeling of power, into a being to whom one may offer thanks. He who is rich will give of his wealth; a proud people need a God to whom they can make *sacrifices*... Religion, within these boundaries, is thus a form of gratitude. A man is grateful for his own existence: to that end he needs a God. – Such a God must be able to work both benefits and troubles; he must be able to play either friend or foe – he is worshipped for good and bad alike. But the castration, *against all nature*, of such a God, making him a God of good alone, would be contrary to human desire. Mankind has just as much need for an evil God as for a good God; it does not owe its own existence to tolerance or kindness alone... What would be the value of a God who knew nothing of anger, revenge, envy, scorn, cunning, or violence? who had perhaps never experienced the rapturous *ecstasies* of victory and of destruction? No one would understand such a God: why should anyone want him? – To be sure, when a nation is on the downward spiral, when it feels its belief in its own future, its hope of freedom slipping away from it, when it begins to see submission as its first priority and the virtues of submission as a condition of self-preservation, then it must *reinvent* its God. He then becomes a hypocrite, timid and modest; he counsels "peace of soul", no more hatred, clemency, "love" of friend and foe. He moralizes

endlessly; he creeps inside every private virtue; he becomes a God for everybody; he becomes a private citizen, a cosmo-politan... Formerly he represented a people, the strength of a people, everything aggressive and thirsty for power in the soul of a people; now he is merely the good God... The truth is that there is no other alternative for Gods: *either* they are the will to power – in which case they are national Gods – or the *incapacity* for power – in which case they have to become *good*...

17.

Wherever the will to power begins to decline, in whatever form, there is always a physiological decline, a *decadence*. The divinity of this *decadence*, shorn of its masculine virtues and passions, is necessarily converted into a God for the physiologically retarded, for the weak. Of course, they do not call themselves the weak; they call themselves "the good"... No further explanation is needed to indicate the moments in history at which the dual fiction of a good and an evil God first becomes possible. The same instinct which prompts a subjugated race to reduce their own God to "goodness-in-itself" also prompts them to expunge all good qualities from the God of their conquerors; they wreak revenge on their masters by making a Devil of the latter's God. – The *good* God, and the Devil: both are the deformed offspring of decadence. – How can we be today so tolerant of the simplistic drivel of Christian theologians as to join in their doctrine that the evolution of the concept of God from "the God of Israel", the God of a people, to the Christian God, the epitome of all goodness, should be described as *progress*? – But even Renan does so. As if Renan had a right to be so simple! The contrary actually stares one in the face. When everything necessary to *ascending* life, when all that is strong, courageous, masterful and proud has been

eliminated from the concept of God; when he has sunk step by step to the level of a staff for the weary, a sheet-anchor for the drowning; when he becomes the poor man's God, the sinner's God, the cripple's God *par excellence*, and the attribute of "saviour" or "redeemer" remains as the single essential attribute of divinity – just *what* is the significance of such a metamorphosis? What does such a reduction of the divine imply? – To be sure: the "kingdom of God" has thereby grown larger. Formerly he had only his own people, his "chosen" people. But since then he has gone wandering, just like his people themselves, into foreign lands; he has forsaken settling down quietly anywhere; until finally he has made his home everywhere, and is the great cosmopolitan – until finally he has the "great majority", and half the earth on his side. But this God of the "great majority", this democrat among gods, has not become a proud pagan God: on the contrary, he remains a Jew, he remains a God in a corner, a God of all the dark hovels and crevices, of all the unhealthy quarters of the world!... His earthly kingdom, now as always, is a kingdom of the underworld, a subterranean kingdom, a ghetto kingdom... And he himself is so pale, so weak, so *decadent*... Even the palest of the pale are able to master him – the metaphysicians, those bloodless albinos of the intellect. They have spun their webs around him for so long that finally he is hypnotized, and begins to spin webs himself, and becomes another arachnid metaphysician. Thenceforth he once more began spinning the world out of his inmost being – *sub specie Spinozae*; thereafter he became ever more pale and transparent – became an "ideal", became "pure spirit", became "the absolute", became "the thing-in-itself"... The *dissolution of a God*: he became a "thing-in-itself"...

18.

The Christian concept of God – God as the patron of the sick, the god as a spinner of webs, the god as a spirit – is one of the most corrupt concepts that has ever been devised on Earth: the lowest, filthiest point in the fluctuating evolution of the God-archetype. God degenerated into *the contradiction of life,* instead of being its transfiguration and eternal *affirmation!* In God a war is declared on life, on nature, on the very will to live! God becomes the formula for every malediction upon the "here and now", for every lie about the "beyond"! In him nothingness is deified, and the will to nothingness is made sacrosanct!...

19.

The fact that the strong races of northern Europe did not repudiate this Christian God does little credit to their aptitude for religion – and little more to their taste. They ought to have been *compelled* to annihilate such a moribund and worn-out abortion of *decadence.* A curse lies upon them because they failed; they have made illness, decrepitude and contradiction a part of their instincts – and since then they have failed to *create* any new gods. Two thousand years have passed – and not a single new god! Instead, there still exists, as if by some intrinsic right, – as if he were the ultimate and maximal expression of the power to create gods, of the *creator spiritus* in mankind – this pitiful God of Christian monotono-theism! This hybrid image of decay, conjured up out of the void, contradiction and vain conceptualising, in which all the symptoms of *decadence,* all the cowardice and sickness of the soul have found their sanction! –

20.

In my condemnation of Christianity I hope I do no injustice to a related religion with an even larger number of believers: *Buddhism*. Both are to be reckoned among the nihilistic religions – they are both *decadence* religions – but they are separated from each other in a very singular way. For the fact that he is able to *compare* them at all, the critic of Christianity is indebted to the scholars of India. – Buddhism is a hundred times more realistic than Christianity – it has a heritage of detached and level problem-solving; it is the product of long centuries of philosophical speculation and evolution. Here, the concept "God" was already abolished before it appeared. Buddhism is the only genuinely *positive* religion to be encountered in history, even in its epistemology (a strict phenomenalism) – it does not speak of the "struggle against *sin*", but, yielding to reality, of the "struggle against *suffering*". Profoundly differentiating itself from Christianity, it has already put the self-deception that lies in moral concepts behind it; it is, to use my own terminology, *beyond good and evil*. – The two physiological facts upon which it rests, and upon which it fixes its main attention are: *first*, an excessive sensitivity to sensation, which manifests itself as a refined capacity for pain, and *secondly*, an extraordinary spirituality, an over-developed concern with concepts and logical procedures, under the influence of which the personal instinct has yielded to a notion of the "impersonal". (– Both of these conditions will be familiar to a few of my readers, the objective ones, by experience, as they are to me –). These physiological states have produced a *depression*, and Buddha tries to combat it by healthy measures. Against it he prescribed a life in the open air, a life of travel; moderation in eating and a careful diet; caution in the use of intoxicants; the same caution in arousing any of the passions that

produce bile, and fire the blood; and finally, *no* anxiety, either on one's own account or on account of others. He encourages ideas that breed either quiet contentment or good cheer – he devises methods to combat the ideas of others. He understands benevolence, the state of goodness, as something which promotes health. *Prayer* is excluded, as is *asceticism*. There is no categorical imperative nor any *compulsion*, even within the walls of a monastery (– it is always possible to leave –). These things would only have been a means of increasing the excessive sensitivity mentioned above. For the same reason he does not advocate any conflict with unbelievers; his teaching resists nothing *more* than revenge, hate, resentment (– "enmity never brings an end to enmity:: the moving refrain of all Buddhism...) And in all this he is right, for it is precisely these emotions which, in view of his main purpose, are *unhealthy*. The spiritual fatigue that he observes, already plainly displayed in excessive "objectivity" (that is, in the individual's loss of interest in himself, in loss of balance and of "egoism"), he combats by directing even spiritual interests back to the *ego*. In Buddha's teaching, egoism is a duty. The "one thing needful", the question "how can you be delivered from suffering", regulates and defines the whole spiritual diet. (– Perhaps one may here recall that Athenian who also declared war upon pure "scientificality", Socrates, who also elevated egoism to the rank of morality, even in the domain of problems.)

<div align="center">21.</div>

The necessary breeding-ground for Buddhism requires a very mild climate, very gentle and liberal customs, and *no* militarism; moreover, it must find its home among the higher and better educated classes. Cheerfulness, quiet and the absence of desire are the chief goals, and they are

attained. Buddhism is not a religion in which perfection is merely a phantom object of aspiration: perfection is actually the norm. –

Under Christianity the instincts of the subjugated and the oppressed come to the fore: it is only those who are at the bottom of the barrel who seek their salvation in it. Here the prevailing *pastime*, the desperate remedy for boredom is the discussion of *sin*, self-criticism, the inquisition of conscience; here the emotion produced by power (called "God") is continually pumped up (by prayer); here the highest good is regarded as unattainable, as a gift, as "grace". Here, too, open behaviour is lacking; suppression and the darkened chamber are the Christian way. Here the body is despised and basic hygiene is denounced as sensual; the Church even ranges itself against cleanliness (the first Christian order after the banishment of the Moors was to close the public baths, of which there were 270 in Cordova alone). Christian, too, is that certain cruelty toward oneself and toward others; hatred of those with different views; the zeal to persecute. Sombre and disquieting ideas are pushed to the foreground; the most desirable states of mind, bearing the most respectable names, are epileptoid; the diet is so regulated as to engender morbid symptoms and over-stimulate the nerves. Christian, again, is mortal enmity to the rulers of the earth, to the "aristocratic" – along with a kind of secret rivalry with them (– one resigns one's "body" to them – one cherishes *only* one's "soul'...). And also Christian is a hatred of the *mind*, of pride, of courage of freedom, of intellectual *libertinage*; Christianity is all hatred of the senses, of joy in the senses, of joy in general...

22.

When Christianity departed from its native soil, that of the lowest orders, the *underworld* of the ancient people, and began seeking power among barbarians, it no longer had to deal with *exhausted* men, but with men still inwardly savage and self-lacerating – in brief, strong men, but flawed men. Here, unlike in the case of the Buddhists, being discontent with oneself, suffering through self, is *not* merely a general sensitivity and susceptibility to pain, but, on the contrary, an inordinate thirst for inflicting pain on others, an overwhelming lust for hostile actions and purges. Christianity had to embrace *barbaric* concepts and values in order to dominate barbarians: sacrifice of the first-born, the drinking of blood as a sacrament, contempt for the intellect and for culture; torture in all its forms, whether physical or not; and the whole gaudy pomp of the cult. Buddhism is a religion for *advanced* races, races that have become kind, gentle and over-spiritualized (– Europe is nowhere near yet ripe for it –): it is a summons that takes them back to peace and cheerfulness, to a careful rationing of the spirit, to a certain hardening of the body. Christianity aims at mastering *beasts of prey*; its method is to make them *sick* – to make weak and feeble is the Christian strategy for taming, for 'civilizing". Buddhism is a religion for the closing, fatigued stages of civilization. Christianity appears before civilization has even begun – and, if need be, it lays its very foundations.

23.

Buddhism, I repeat, is a hundred times more aloof, more honest, more objective. It no longer has to *justify* its pains, its capacity for suffering, by interpreting them as sin – it simply says what it feels, "I suffer". To the

barbarian, however, suffering in itself is almost indecent: what he needs, first of all, is an explanation as to *why* he suffers. (His instinct urges him to deny his suffering altogether, or to endure it in silence.) Here the word "Devil" was a blessing: man had to have an omnipotent and terrifying enemy – there was no need to be ashamed of suffering at the hands of such a foe.

– At the foundations of Christianity there are several subtleties that belong to the Orient. Above all, it knows that it is of very little consequence whether a thing be true or not, so long as it is *believed* to be true. Truth and *belief:* two wholly distinct conceptual worlds, two almost *diametrically opposite* worlds – the road to the one and the road to the other lie miles apart. To understand this fact thoroughly – this is almost enough, in the Orient, to *earn the rank* of sage. The Brahmins knew it, Plato knew it, every student of the esoteric knows it. When, for example, a man gets *pleasure* from the belief that he has been redeemed from sin, it is *not* necessary for him to be actually sinful, but merely to *feel* sinful. But if faith is thus exalted above everything else, it necessarily follows that reason, knowledge and inquiry have to be discredited: the road to the truth becomes a *forbidden* road. – *Hope*, in its intense form, is a much more powerful stimulant to life than any instant of joy can ever be. Sufferers must be sustained by a hope so strong that no conflict with reality can smash it – so strong, indeed, that no *fulfilment* could ever satisfy it: a hope reaching out beyond this world. (Precisely because of this power that hope has of making the sufferer hold out, the Greeks regarded it as the evil of evils, as the most *malignant* of evils; it festered at the very source of all evil.) – In order that *love* may be possible, God must become a person; in order that the lower instincts may have a voice, God must be young. To satisfy the lust of women a beautiful saint must appear on the

scene, and to satisfy men there must be a virgin. These icons are prerequisite if Christianity is to assume mastery over a land in which some cult of Aphrodite or Adonis has already established the *concept* of what religious worship ought to be. To insist upon *chastity* greatly strengthens the vehemence and inner intensity of the religious instinct – it makes the cult warmer, more enthusiastic, more soulful. – Love is the state in which man sees things in the most *distorted* light. The force of illusion reaches its apex here, and so does the capacity for sweetening, for *transforming*. A man in love endures more than at any other time; he submits to anything.

The objective was to devise a religion which would allow one to love: by this means the worst suffering that life has to offer is overcome – it is scarcely even noticed. – So much for the three Christian virtues: faith, hope and charity: I call them the three Christian *palliatives*. – Buddhism is in too late a stage of development, too positive, to be cynical in any such way. –

<div align="center">24.</div>

Here I only touch upon the problem of the *origin* of Christianity. The *first* thing necessary to its solution is this: that Christianity is to be understood only by examining the soil from which it grew – it is *not* a counter-movement against the Jewish instinct; it is actually its inevitable consequence, one more step in the awe-inspiring logic of the Jews. In the words of the Saviour, "salvation is of the Jews". – The *second* thing to remember is this: that the psychological type of the Galilean is still recognizable, but only in a completely degenerate form (which is at once mutilated and overburdened with foreign traits) could it serve in the manner in which it has been designed: as a *Saviour* of

mankind.

– The Jews are the most remarkable people in the history of the world, for when they were confronted with the choice between being or nothingness, they chose, with perfectly uncanny conviction, to be *at any price*: this price was a radical *falsification* of all nature, of all naturalness, of all reality, of the whole inner world, as well as the outer. They defined themselves as against all those conditions under which, hitherto, a people had been able to live, or had even been *permitted* to live; out of themselves they evolved an idea which stood in antithesis to *natural* conditions – they distorted religion, civilization, morality, history and psychology until each became a *contradiction of its natural values*. We encounter the same phenomenon later on, in an incalculably vaster form, but only as a copy: the Christian church, in contrast to the "people of God", shows a complete lack of any claim to originality. For precisely this reason the Jews are the most *fateful* people in the history of the world: their influence has so falsified the reasoning of mankind that today the Christian can embrace anti-Semitism without realizing that he is no more than the *ultimate consequence of the Jews*.

In my "Genealogy of Morals" I give the first psychological explanation of the concepts underlying those two antithetical concepts, a *noble* morality and a *resentment* morality, the latter deriving from a *denial* of the former. The Judaeo-Christian moral system belongs to this latter division, in every detail. In order to be able to reject everything representing an ascending evolution of life – well-being, power, beauty, self-affirmation – the instinct of *resentment*, here become pure genius, had to invent *another* world in which the affirmation of life appeared as evil and abominable. Psychologically, the Jews are a

people gifted with a very enduring vitality, so much so that when they found themselves facing impossible conditions of life they chose voluntarily, with the most profound instinct for self-preservation, the side of all *decadent* notions – *not* as if dominated by them, but divining in them a power by which "the world" could be defied. The Jews are the very opposite of *decadents*: they have simply been forced into *acting* in that guise, and with a degree of skill approaching the ultimate level of histrionic genius they have managed to put themselves at the head of all *decadent* movements (– for example, the Christianity of Paul –), and so make of them something stronger than any party *affirmative* to life. For the sort of men who seek to grasp power under Judaism and Christianity, – that is to say, to the *priestly*, – *decadence* is no more than a *means* to an end. Men of this sort have a vested interest in making mankind *sick*, and in commingling the values of "good" and "bad", "true" and "false" in a manner that is not only dangerous to life, but also betrays it.

25.

The history of Israel is invaluable as a typical history of an attempt to *denaturalize* all natural values: I shall indicate five facts which bear this out. Originally, and above all in the time of the monarchy, Israel maintained the *correct* attitude of things, which is to say, the natural attitude. Its Jahveh was an expression of its consciousness of power, their joy in themselves, their hopes for themselves: to him the Jews looked for victory and salvation and through him they hoped for nature to give them whatever was necessary to their existence – above all, rain. Jahveh is the God of Israel, and *consequently* the God of justice: this is the logic of every race that has power in its hands and a good conscience in wielding it. In the

religious ceremonial of the Jews both aspects of this self-affirmation stand revealed. The nation is grateful for the great destiny that has enabled it to obtain dominion; it is grateful for the seasons, and for the good fortune attending its livestock and its crops. – This state of things remained an ideal for a long while, even after it had been tragically cancelled out by anarchy within and the Assyrians from without. But the people still retained, as its supreme desire, that vision of a king who was at once a gallant warrior and an upright judge – a vision best embodied in the archetypal prophet (i.e., critic and satirist of the hour), Isaiah. – But every hope remained unfulfilled. The old God *could no longer do* what he used to do. He ought to have been abolished. But what actually happened? Simply this: the conception of him was changed and denaturalized; this was the price that had to be paid for keeping him. – Jahveh, the god of "justice" – he is in accord with Israel *no longer*, he no longer expresses the national egoism; he is now a God only under certain conditions... The new public conception of this God becomes a weapon in the hands of priestly agitators, who interpret all good fortune as a reward and all misfortune as a punishment for disobedience to him, for "sin": that most fraudulent of all imaginable interpretations, whereby a "moral world order" is established, and the fundamental concepts, "cause" and "effect", are inverted. Once natural causality has been swept out of the world by doctrines of reward and punishment, some sort of *anti-causality* becomes necessary: and all other kinds of the denial of nature follow it. A God who *demands* – in place of a God who helps, who gives counsel, who is fundamentally a name for every joyous inspiration of courage and self-reliance... *Morality* is no longer a reflection of the conditions which make for the prosperity and development of the people; it is no longer the primary life-instinct; instead it has become abstract,

the antithesis of life – a fundamental perversion of the imagination, an "evil eye" fixed on all things. *What* is Jewish, *what* is Christian morality? Chance robbed of its innocence; misfortune tainted with the concept of "sin"; well-being as a danger, as a "temptation"; a physiological disorder engendered by the poisonous worm of conscience...

26.

The concept of God falsified; the concept of morality falsified; – but even here Jewish priests' treachery did not stop. The entire *history* of Israel ceased to be of any value: away with it! – These priests perpetrated that miracle of falsification of which a great part of the Bible is documentary evidence; with an unparalleled degree of contempt, and flaunting all tradition and all historical reality, they translated the past of their people *into religious terms*, which is to say, they converted it into an idiotic mechanism of salvation whereby all offences against Jahveh were punished and all devotion to him was rewarded. We would feel this act of historical falsification far more shamefully if familiarity with the *ecclesiastical* interpretation of history for thousands of years had not blunted our hunger for veracity *in historicis*. And the philosophers support the church: the *lie* about a "moral world order" permeates the evolution of philosophy, even to the most modern strands. What is the meaning of a "moral world order"? That there exists a thing called the will of God which, once and for all time, determines what man ought to do and what he ought not to do; that the value of a nation, or of an individual, is to be measured by the extent to which they or he obey this will of God; that the destinies of a people or of an individual are controlled by this will of God, which rewards or punishes according to the degree of obedience.

– In place of that pitiable lie, *reality* has this to say: the priest, a filthy human parasite who can exist only at the expense of every healthy form of life, takes the name of God in vain: he calls that state of human society in which the priest himself determines the value of all things "the kingdom of God"; he calls the means whereby that state of affairs is attained "the will of God"; with cold-blooded cynicism he assesses all nations, all epochs and all individuals by the extent of their subservience or opposition to the power of the priestly rule. Observe him at work: under the hand of the Jewish priesthood the *great* age of Israel became an age of decline; the Exile, with its long series of misfortunes, was transformed into an eternal punishment for that great age – during which priests had not yet come into existence. Out of the powerful and *totally free* heroes of Israel's history they fashioned, according to their changing needs, either wretched bigots and hypocrites or men who were entirely "godless". They simplified the psychology of every great event to the idiotic formula: "obedience *or* disobedience to God". – Then they went a step further: the "will of God" (in other words the conditions necessary for preserving the power of the priests) had to be determined – and to this end they had to have a "revelation". In plain words, a gigantic literary fraud had to be perpetrated, and "holy scriptures" had to be concocted – and so, with the utmost hieratic pomp, and days of penance and much lamentation over the long days of "sin" now ended, these lies were duly published. The "will of God", it appears, had long stood established; the root of all evil was that mankind had neglected the "holy scriptures"... But the "will of God" had already been revealed to Moses... What happened? Simply this: the priest had formulated, once and for all time and with the strictest precision, what stipends were to be paid to him, from the largest to the smallest (– not forgetting the most appetizing cuts of

meat, for the priest is a great consumer of beef); in brief, he let it be known *exactly what he wanted*, what "the will of God" was.... From this time forward things were so ordered that the priest became *indispensable everywhere*; at all the great natural events of life, at birth, at marriage, in sickness, at death, not to mention at the "sacrifice" (meal-times), the holy parasite appeared and proceeded to denaturalize things – or in his own phrase, to "sanctify" them... For this should be understood: that every natural habit, every natural institution (the state, the administration of justice, marriage, the care of the sick and of the poor), everything demanded by the life-instinct, in short, everything that has any value *in itself*, is reduced to absolute zero, made *antithetical* to all value by the parasitism of priests (or the "moral world order"). The fact requires a sanction – a *value-judging* power becomes necessary, and the only way it can *quantify* such values is by denying nature... The priest devalues and desecrates nature: it is only at this price that he can exist at all. – Disobedience to God, which actually means to the priest, to "the law", now acquires the name of "sin"; the means prescribed for "reconciliation with God" are precisely the means by which subjugation to the priest is effected; for he alone can "save". Psychologically considered, "sins" are thus indispensable to every society organized by a priesthood; they are the only reliable weapons of power; the priest *lives* upon sins; it is vital to him that there be "sinning"... Supreme law: "God forgives him that repents" – in plain words, *him that submits to the priest*. –

27.

Christianity sprang from a putrid soil so *corrupt* that on it everything natural, every natural value, every *reality* was opposed by the deepest instincts of the ruling class – it

arose as a war to the death upon reality, that has never been surpassed. The "holy people", who had adopted priestly values and priestly names for all things, and who, with a fearful and inexorable logic, had rejected everything else on earth as "unholy", "worldly", "sinful" – this people forged its instinct into a final formula that was logical to the point of self-negation: as *Christianity* it denied even the last remaining form of reality, the "holy people", the "chosen people", – *Jewish* reality itself. This phenomenon is of the first order: the little rebel movement which took the name of Jesus of Nazareth is simply the Jewish instinct *regurgitated* – in other words, it is the priestly instinct that can no longer endure the priest as a fact; is the invention of a state of existence even *more fantastic* than any before it, of a vision of life even *more unreal* than that conditioned by an ecclesiastical organization. Christianity actually *negates* the church...

I am unable to determine the target of the insurrection said to have been led (whether rightly or *wrongly*) by Jesus, if it was not the Jewish church – "church" being used here in exactly the same sense that the word has today. It was an insurrection against the "good and just", against the "prophets of Israel", against the whole social hierarchy – *not* against corruption, but against caste, privilege, order, tradition. It was *disbelief* in "superior men," a *No* spat at everything that priests and theologians stood for. But the hierarchy that was called into question, if only for a moment, by this movement was the brick-pile upon which, above everything, the Jewish nation was perched in the midst of the "flood waters" – it represented their *last* possibility of survival; it was the final redoubt of their independent political existence; an attack upon it was an attack upon the most profound national instinct, the most tenacious national will to live, that has ever manifested itself on earth. This holy

anarchist, who rabble-roused the people of the abyss, the outcasts and "sinners", the *Chandala* of Judaism, to rise in revolt against the ruling order – using language which, if the Gospels are to be credited, would get him exiled to Siberia today – this man was a political criminal, at least in so far as it was possible to be one in such an *absurdly unpolitical* community. This is what brought him to the Cross: the proof is to be found in the inscription that was put upon that Cross. He died for *his own* sins – there is not the slightest ground for believing, no matter how often it is asserted, that he died for the sins of others. -

<div align="center">28.</div>

As to whether he himself was conscious of this contra-diction – or whether he was merely *felt* to be this contradiction – that is quite another question. Here, for the first time, I touch upon the problem of the *psychology of the Saviour*. – I must confess that there are very few books which offer me more problems than the Gospels. These difficulties are quite different from those which enabled the learned curiosity of the German mind to achieve one of its most unforgettable triumphs. It is a long while since I, like all other young scholars, enjoyed with all the clever pedantry of a refined philologist the work of the incomparable Strauss. I was then twenty years old: now I am too serious for that sort of thing. What do I care for the contradictions of "tradition"? How can anyone call the legends of saints "traditions"? The histories of saints are the most dubious variety of literature in existence; to examine them by the scientific method, in the *entire absence of corroborating documents*, seems to me doomed from the start – mere learned idling.

29.

What concerns *me* most is the psychological type of the Saviour. This type *might* be depicted in the Gospels, in however mutilated a form and however much overloaded with extraneous traits – that is, in spite of the Gospels; just as the figure of Francis of Assisi shows itself in his legends *in spite* of his legends. It is not a question of mere truth about what he did, what he said and how he actually died; the question is, *whether* his type is still conceivable, whether it has been handed down to us by tradition. – All the attempts that I know of to decipher the *history* of a "soul" in the Gospels seem to me to reveal only a despicable psychological lack. M. Renan, that mountebank *in psychologicus*, has contributed the two *most inappropriate* precepts possible in explaining the type of Jesus: the notion of the *genius* and of the *hero*. But if anything is essentially unevangelical, it is surely the concept of the hero. What the Gospels make instinctive is precisely the opposite of all heroic struggle, of all taste for conflict: the incapacity for resistance here becomes morality: ("resist not evil !" – the most profound saying in the Gospels, and perhaps the true key to them), the blessed state of peace, of gentleness, of the *inability* to be anyone's enemy. What is the meaning of "glad tidings"? – True life, eternal life has been found – it is not merely promised, it is here, it is *within* you; it is the life that lives in love, free from all retreats and exclusions, without distance. Everyone is the child of God – Jesus claims nothing for himself alone – as the child of God each man is the equal of every other man... Imagine making Jesus a *hero*! – And what a worse misunderstanding is the word "genius"! Our whole conception of the "spiritual", the whole conception of our civilization, could have no meaning in the world that Jesus lived in. In the strict sense of the physiologist, a quite different word ought to

be used here: the word "idiot!"... We recognize that there is a morbid sensibility of the *sense of touch* which causes those suffering from it to recoil from every contact, and from every grasping of a solid object. Brought to its logical conclusion, such a physiological condition becomes an instinctive hatred of *all* reality, a flight into the "intangible", into the "inconceivable"; an anti-pathy for all form, for all concepts of time and space, for everything established – customs, institutions, the Church – ; a feeling of being at home in a world untouched by any sort of reality, a purely "inner" world, a "true" world, an "eternal" world "The Kingdom of God *is within you*"...

<div align="center">30.</div>

The *instinctive hatred of reality*: consequence of an extreme susceptibility to pain and suffering – so great that merely to be "touched" becomes unendurable, for every sensation is too profound to bear.

The instinctive exclusion of all aversion, all hostility, all limitations and distances in feeling: consequence of an extreme susceptibility to pain and suffering – so great that it senses all resistance, all compulsion to resistance, as an unbearable *anguish* (– that is to say, as *harmful*, as deprecated by the instinct for self-preservation –), and regards blessedness (pleasure) as possible only when it is no longer necessary to resist anybody or anything, however evil or dangerous – love, as the only, as the *last* possibility of life...

These are the two *physiological realities* upon and out of which the doctrine of salvation and redemption has evolved. I term them a *sublime super-evolution of hedonism* rearing upon a thoroughly morbid axis. Most closely

related to them, albeit with a large addition of Greek vitality and nervous energy, is Epicureanism, the pagan theory of salvation. Epicurus was a typical *decadent*: I was the first to recognize him as such. – The fear of pain, even of infinitesimal pain – cannot end in anything but a *religion of love*...

<p style="text-align:center">31.</p>

I have already covered my answer to the problem. The presumption is that the type of the Saviour has reached us only in a vastly distorted form. This distortion is very likely: there are several reasons why such a type should not be handed down in a pure form, complete and free of mutation. The environment in which this bizarre figure moved must have left its mark upon him, and more must have been imprinted by the history, the *fate*, of the early Christian community; the latter must have embellished the type retrospectively with traits which can be understood only in terms of war and of propaganda. That strange and sick world into which the Gospels lead us – a world apparently out of a Russian novel, in which the scum of society, neurosis and "childish' idiocy keep a mad tryst – must, at very least, have *coarsened* the type: the first disciples, in particular, must have been forced to tranfigure a being visible only in symbols and abstractions into their own crude effigy, in order to understand it at all – in their sight the type could *exist* only after it had been recast in a familiar mould The prophet, the Messiah, the future judge, the preacher of morals, the miracle-worker, John the Baptist – all these chances to misunderstand the type... Finally, let us not underrate the *proprium* of all extreme, and especially all sectarian veneration: it tends to eradicate from the venerated object all its original traits and idiosyncrasies – *and often fails to see them entirely*. It is of great regret that

no Dostoyevsky lived in the epoch of this most interesting *decadent* – I mean someone who would have felt the visceral charge of such a compound of the sublime, the morbid and the childish. In the last analysis, the type, as a *decadent* type, *may* actually have been of a freak complexity and confusion: such a possibility is not to be overlooked. Nevertheless, the likelihood seems to be against it, for in that case tradition would have been particularly accurate and objective, whereas we have reasons for assuming the exact contrary. Meanwhile, there is a gaping contradiction between the peaceful preacher of the mount, lakeshore and fields, who appears like a new Buddha on a soil very unlike India's, and the aggressive fanatic, the mortal enemy of theologians and priests, who stands wickedly glorified by Renan as *"le grand maitre en ironie"*. I myself have no doubt that this excess venom (and no less measure of *spirit*) infested the concept of the Master only as a result of the excited nature of Christian propaganda: we all know the unscrupulousness of sectarians when they set out to transform their leader into an apologia for themselves. When the first Christians had need of an adroit, aggressive and maliciously understated theologian to oppose other theologians, they *created* a "God" that met that need, just as they put into his mouth without hesitation those utterly unevangelical ideals that were necessary to their deceit – "the Second Coming", "the Last Judgment", all sorts of temporal expectations and promises. –

32.

I can only repeat that I resist all efforts to introduce the fanatic into the figure of the Saviour: the very word *imperieux*, used by Renan, is alone enough to *annul* the type. What the "glad tidings" tell us is simply that there

are no more contradictions; the kingdom of heaven belongs to *children*; the faith that is voiced here is no more an embattled faith – it is at hand, it has been from the very beginning, it is a sort of recurring childishness of the spirit. The physiologists, at least, are familiar with such a retarded and imperfect puberty in a living organism, as the result of degeneration. A faith of this sort is not angry, it does not censure, it does not defend itself: it does not brandish "the sword" – it does not realize how it will one day set man against man. It does not manifest itself either by miracles, or by rewards and promises, or by "scriptures": it is in itself its own miracle, its own reward, its own promise, its own "kingdom of God". Neither does this faith formulate itself – it simply *lives*, and so resists formulas. To be sure, the random nature of environment, of education, determines the birth of certain concepts: in primitive Christianity one finds *only* concepts of a Judaeo-Semitic nature (– eating and drinking at communion belongs to this category – a ritual which, like everything else Jewish, has been sadly abused by the Church). But let us be careful not to see in all this anything more than a symbolic language, a semiotic, an opportunity to speak in metaphor. It is only on the condition that nothing he says is to be taken literally that this anti-realist is able to speak at all. Among Hindus he would have made use of the concepts of Sankhya, among Chinese he would have employed those of Lao-tse – and would not have noticed the difference. – With a little descriptive license, one might actually call Jesus a "free spirit" – he cares nothing for what is established: the word *killeth*, everything established *killeth*. 'The idea of "life" as an *experience*, as he alone perceives it, stands opposed to any kind of word, formula, law, faith or dogma. He speaks only of inner things: "life" or "truth" or "light" is his word for the innermost essence – in his view everything else, the whole of reality, all nature, even language itself, has

significance only as sign, as metaphor. – Here it is of paramount importance to be led into no prejudice by the temptations lying in Christianity, or in ecclesiastical values: such a symbolism *par excellence* stands outside of all religion, all notions of divine worship, all history, all natural science, all worldly experience, all knowledge, all politics, all psychology, all books, all art – his "wisdom" is precisely the *pure ignorance* of all such things. He has never heard of culture; he doesn't have to declare war on it – he doesn't even bother to deny it... The same thing may be said of the *state*, of the whole social order, of work, of war – he has no reason for denying "the world", for he knows nothing of the ecclesiastical concept of "the world"... *Denial* is the very thing that is impossible for him. – In the same way he lacks a dialectical capacity, and has no belief that an article of faith, a "truth", may be proved by reason (– *his* proofs are inner "lights", inner sensations of pleasure and self-approval, mere "proofs of power" –). Such a doctrine cannot gainsay: it does not acknowledge that other doctrines exist, or *can* exist, and is wholly incapable of imagining any opinion opposed to its own... If anything of this sort is ever encountered, it laments its blindness with sincere sympathy – for it alone sees the light – but it does not make objections...

33.

In the entire psychology of the "Gospels" the concept of guilt and punishment are lacking, and likewise that of reward. "Sin", which means anything that puts distance between God and man, is abolished – *this is precisely the "glad tidings"*. Eternal bliss is not promised, nor is it tied to any conditions: it is conceived as the only reality – what remains consists merely of signs for articulating it.

The *results* of such a point of view project themselves into

a new *way of life*, the true evangelical way of life. It is not a "belief" that distinguishes the Christian; he is distinguished by a *different* mode of action. He offers no resistance, either by word or by will, to those who oppose him. He makes no distinction between strangers and countrymen, Jews and Gentiles (one's "neighbour" ,of course, means a fellow-believer, a Jew). He is angry with no-one, and he despises no-one. He neither appeals to the courts of justice nor heeds their mandates ("Swear not at all"). He would never under any circumstances divorce his wife, even if he had proofs of her adultery. – And all of this is founded on one principle; all of it derives from one instinct. –

The life of the Saviour was simply a process of carrying out of *this* way of life – and so was his death... He no longer needed any formula, any ritual in his communications with God – not even prayer. He had rejected the whole Jewish doctrine of repentance and atonement; he knew that it was only by a *way of life* that one could feel "divine", "blessed", "evangelical", a "child of God". *Not* by "repentance", not by "prayer and forgiveness" is the way to God found: *only evangelical practice* leads to God – it *is itself* "God"! – What the Gospels *abolished* was the Judaism of the concepts of "sin", "forgiveness of sin", "faith", "redemption through faith" – the whole *ecclesiastical* dogma of the Jews was denied by the "glad tidings".

The profound instinct which drives the Christian to live so that he will feel that he is "in heaven" and is "immortal", despite myriad reasons for feeling that he is *not* "in heaven": this is the sole psychological reality in "salvation". – A new way of life, *not* a new faith.

34.

If I understand anything at all about this great symbolist, it is this: that he regarded as realities, as "truths", only *inner* realities – that he saw everything else, everything natural, temporal, spatial and historical, merely as signs, as the stuff of metaphor. The concept of "the Son of God" does not connote a concrete person in history, an isolated and definite individual, but an "eternal" fact, a psychological symbol divorced from the concept of time. The same thing is supremely true of the *God* of this typical symbolist, of the "kingdom of God", and of the "child of God". Nothing could be more un-Christian than the *crude ecclesiastical notions* of God as a *person*, of a 'kingdom of God" that is to come, of a "kingdom of heaven" *in the beyond*, and of a "son of God" as the *second person* of the Trinity. All this – if I may be excused the phrase – is like smashing a fist into the eye (and what an eye!) of the Gospels: a mockery of symbols that amounts to *world-historical cynicism*... But it is patently obvious what is meant by the symbols "Father" and "Son" – though not obvious, of course, to everyone – : the word "Son" expresses *entry* into the collective feeling that there is a transformation of all things (beatitude), and the word "Father" expresses *this feeling itself* – the sensation of eternity and of perfection. – I am ashamed to re-recall what the church has made of this symbolism: has it not set an Amphitryon story at the threshold of the Christian 'faith"? And a dogma of "immaculate conception" for good measure?... *And it has thereby fatally tainted conception* –

The "kingdom of heaven" is a state of the heart – not something to come "beyond the world" or "after death". The whole idea of natural death is *absent* from the Gospels: death is not a bridge, not a transition; it is absent

because it belongs to a quite different, virtual world, useful only as a symbol. The "hour of death" is not a Christian concept – "hours", time, physical life and its crises have no existence for the bearer of "glad tidings"...

The "kingdom of God" is not something that men wait for: it has no yesterday and no tomorrow, it will not arrive at the "millennium" – it is an experience of the heart, it is everywhere and it is nowhere...

35.

This "bearer of glad tidings" died as he lived, as he taught – not to "save mankind", but to show mankind how to live. It was a *way of life* that he bequeathed to mankind: his bearing before the judges, before the officers, before his accusers and in the face of bitter lies – his demeanour on the *Cross*. He does not resist; he does not defend his rights; he makes no effort to avert the most extreme penalty – more, *he invites it*... And he prays, he suffers, and he loves *with* those, *in* those, who do him evil... His words to a crucified *thief* contain his entire Gospel. "That was truly a *divine* man, a child of God!", said the thief. "If you truly feel this," replied the Saviour, *"you are already in paradise."*

Not to defend oneself, *not* to show anger, *not* to lay blame... On the contrary, to submit even to an evil man – to *love* him...

36.

– We *free* spirits – we are the first to have the prerequisite to understanding what nineteen centuries have misunderstood – the instinct and passion for integrity which wages war upon the "holy lie" even more than

upon all other lies... Mankind has been unutterably removed from our benevolent and cautious neutrality, from that discipline of the spirit which alone makes possible the divining of such strange and subtle things: mankind has always sought, with shameless egoism, *its own* advantage therein; has created the *Church* out of antipathy to the Gospels...

Anyone seeking signs of an ironic divinity's hand in the great tragedy of existence would find substantial evidence in the *stupendous question-mark* that is called Christianity. That mankind should bend on its knees before the very antithesis of what was the origin, the meaning and the *law* of the Gospels – that in the concept of the "church" the very things should be sanctified that the "bearer of glad tidings" regarded as *beneath* him and *behind* him – it would be impossible to surpass this as a grand example of *world-historical irony* –

37.

Our age is proud of its historical sense: how, then, could it delude itself into believing that the *crude fable of the miracle-worker and Saviour* constituted the origins of Christianity – and that everything spiritual and symbolic in it only developed later? On the contrary, the whole history of Christianity – from the death on the Cross onward is the history of a progressively cruder misunderstanding of an original symbolism. With every extension of Christianity amongst ever larger and coarser masses, ever less capable of grasping the principles that spawned it, the need grew to make it more and more *vulgar,* and more *barbarous* – it absorbed the doctrines and rites of every *subterranean* cult of the *Roman Empire,* and the absurdities engendered by all sorts of morbid reasoning. It was the fate of Christianity that its faith had

to become as morbid, as low and as vulgar as the needs it had to succour were morbid, low and vulgar. This *morbid barbarism* finally ascends to power in the form of the Church – the Church, that incarnation of deadly hostility to all honesty, to all *loftiness* of soul, to all discipline of the spirit, to all open-hearted and benevolent humanity. – *Christian* values – *noble* values: it is only we, we *free* spirits, who have re-established this greatest of all antitheses in values!...

<p style="text-align:center">38.</p>

– I cannot, at this juncture, suppress a sigh. There are days when I am haunted by a feeling blacker than the blackest melancholy – *contempt of mankind*. Let me leave no doubt as to *what* I despise, *whom* I despise: it is the man of today, the man with whom I am an unfortunate contemporary. The man of today – I am suffocated by his foetid breath!... Toward the past, like all men of learning, I am full of tolerance, which is to say, *magnanimous* self-control: with gloomy caution I traverse whole millennia of this mad-house world, call it "Christianity", "Christian faith" or the "Christian Church", as you will – I take care not to hold mankind responsible for its manifest lunacies. But my feelings change and erupt irresistibly the moment I enter modern times, *our* times. Our age *knows better*... What was formerly merely sick, now becomes obscene – it is obscene to be a Christian today. *And here my disgust begins.* – I look about me: not a single word survives of what was once called "truth"; we can no longer bear to hear a priest utter the word. Even a man with the most modest claims to integrity *must* know that a theologian, a priest, a pope of today not only errs when he speaks, but actually *lies* – and that he can no longer escape blame for his lies through "innocence" or "ignorance". The priest knows as well as anyone that there is no longer any

"God", or any "sinner", or any "Saviour" – that "free will" and the "moral world order" are filthy lies – : serious reflection, the profound self-conquest of the spirit, *allow no man* to pretend that he does *not* know this reality... All the ideas of the Church are now recognized for what they are – as the worst hypocrisies in existence, invented to debase nature and all natural values; the priest himself is seen as he clearly is – as the most dangerous form of parasite, as the most venomous spider of all creation We know, our *conscience* now knows – exactly *what* the real value of all those sinister inventions of priest and Church has been and *what ends they have served*, with their degradation of humanity to a state of self-violation, the very sight of which excites disgust – the concepts of "the other world", "the Last Judgment", "the immortality of the soul", the "soul" itself: they are all instruments of torture, systems of cruelty, whereby the priest achieves and retains dominance... Everyone knows this, *but nevertheless things remain unchanged*. What has become of the last vestige of decency, of self-respect, when our statesmen, in all other ways an unprejudiced class of men, thoroughly anti-Christian in their acts, now call themselves Christians and go to Communion?... A prince at the head of his armies, magnificent as the expression of the egotism and arrogance of his people – and yet professing, *without* any shame, that he is a Christian!... *Whom*, then, does Christianity deny? *What* does it call "the world"? To be a soldier, to be a judge, to he a patriot; to defend oneself; preserving one's honour; to desire one's best advantage; to be *proud*... every act of every hour, every instinct, every valuation that leads to *action*, is today anti-Christian: what a *monster of falsehood* modern man must be that nevertheless *unashamed* to be called a Christian! –

39.

– To resume, I shall now tell you the *true* history of
Christianity. – The very word "Christianity" carries a
misunderstanding – basically there was only one
Christian, and he died on the Cross. The "Gospels" *died*
on the Cross. What, from that moment onward, was
known as the "Gospels" was the very opposite of what *he*
had embodied: "bad tidings", an *anti-angel*. It is wrong to
the point of absurdity to see in "faith", and particularly
the faith in salvation through Christ, the distinguishing
mark of the Christian: only the Christian *way of life*, the
kind of life lived by him who died on the Cross, is
Christian... Even to this day *such* a life is possible, and for
certain men even necessary: genuine, primitive
Christianity will remain possible in all ages... *Not* faith,
but actions; above all, an *avoidance* of actions, a different
state of *being*... States of consciousness, faith of any sort,
the acceptance, for example, of anything as true – as every
psychologist knows, the value of these things is
completely negligible and fifth-rate compared to that of
the instincts: strictly speaking, the whole concept of
intellectual causality is false. To reduce being a Christian,
the state of Christianity, to an acceptance of truth, to a
mere phenomenon of consciousness, is to negate
Christianity. *In fact, there have been no Christians at all.* The
"Christian" – he who for two thousand years has been
called Christian – is simply a psychological self-delusion.
Closely examined, it appears that, *despite* all his "faith",
he has been ruled *only* by his instincts – and what
instincts! – In all ages – for example, in the case of Luther
– "faith" has been no more than a cloak, a pretext, a *screen*
behind which the instincts have played their game – an
astute *blindness* to the dominance of *certain* instincts... I
have already called "faith" the uniquely Christian form of
cunning – people always *talk* of their "faith" and *act*

according to their instincts... In the world of ideas of the Christian there is nothing that even fringes on reality: on the contrary, we can recognize an instinctive *hatred* of reality as the driving force, the *only* force at the roots of Christianity. What follows from there? That even here, in *psychology* as well, there is a radical error, which is to say one conditioning the essence, which is to say, the *substance*. Take away *one* idea and put a genuine reality in its place – and the whole of Christianity crumbles to dust! – Viewed objectively, this strangest of all phenomena, a religion not only defined by errors, but inventive and ingenious *only* in devising pernicious errors, poisonous to life and to the heart – remains a *spectacle for the gods* – for those gods who are also philosophers, and whom I have encountered, for example, in the celebrated dialogues at Naxos. At the moment when their *disgust* leaves them (– and leaves us!) they will be grateful for the spectacle afforded by the Christian: it is perhaps because of this curious exhibition alone that the wretched little star called Earth deserves a divine glance, a glimmer of divine interest... Therefore, let us not underestimate the Christian: the Christian, false *to the point of innocence*, is far above the ape – when applied to the Christians, a well-known theory of descent becomes a mere compliment...

40.

– The fate of the Gospels was decided by death – it hung on the "Cross."... It was only death, that unexpected and shameful death; it was only the Cross, which was usually reserved for the *canaille* only – it only this appalling paradox which brought the disciples face to face with the real enigma: *"Who was that? What was that?"* – The feeling of profound affront and dismay; the suspicion that such a death might be the very *refutation* of their

cause; the terrible question, "Why has this happened?" –
this state of mind is only too easy to understand. Here
everything *had* to be necessary; everything must have a
meaning, a reason the highest sort of reason; the love of
a disciple denies all chance. Only then did the chasm of
doubt yawn asunder: "*Who* put him to death? *Who* was
his natural enemy?" – this question flashed up like a
thunderbolt. The answer: *ruling* Judaism, its dominant
class. From that moment on, one found oneself in mutiny
against the social order, and began to understand Jesus
too as being *in revolt against the social order.* Until then this
militant, this negative element in his image had been
lacking; in fact, he had appeared to embody its opposite.
Obviously, the little community had *not* understood the
most important thing of all: the supreme example offered
by this way of dying, the freedom from and superiority
over every feeling of *resentment* – a clear sign of how little
he was understood at all! All that Jesus could hope to
accomplish by his death was to offer the strongest
possible *proof,* or test, of his teachings in the most public
manner. But his disciples were very far from *forgiving* his
death – though to have done so would have been
evangelic in the highest degree; and neither were they
prepared to *offer themselves,* with contentment and
serenity of heart, for a similar death... On the contrary, it
was perhaps the most unevangelical of impulses, *revenge,*
that now gripped them. It seemed impossible that the
cause should perish with his death: "retribution" and
"judgment" were necessary (– yet what could be less
evangelical than "retribution", "punishment", and
"sitting in judgment"!) – Once more the popular
expectation of a messiah came to the fore; attention was
focused on a historic moment: the "kingdom of God" is
coming, to pass judgment upon his enemies... But in all
this there was a complete misunderstanding: imagine the
"kingdom of God" as a last act, as a mere promise! The

Gospels had been, in fact, the incarnation, the fulfilment, the *realization* of this "kingdom". Such a death *was* the very essence of this "kingdom of God". It was only now that all the contempt for, and bitterness against Pharisees and theologians began to be etched into the character of the Master – he was thereby *transformed into* a Pharisee and theologian himself! On the other hand, the savage veneration of those completely unhinged souls could no longer endure the Gospel doctrine, taught by Jesus, of the equal right of all men to be children of God: their revenge took the form of *exalting* Jesus in extravagant fashion, and thus distancing him from themselves: just as, in earlier times, the Jews, to avenge themselves upon their enemies, had separated themselves from their God, and elevated him to the greatest heights. The *One* God and the *One* Son of God: both products of bitter *resentment*...

<div align="center">41.</div>

– And so an absurd problem reared itself: "How *could* God allow it?" To which the deranged reason of the little community formulated an answer that was terrifying in its absurdity: God gave his son as a *sacrifice* for the forgiveness of sins. At once there was an end of the Gospels! *Sacrifice for sin*, in its most repulsive and barbarous form: sacrifice of the *innocent* for the sins of the guilty! What appalling paganism! – Jesus himself had done away with the very concept of "guilt", he had denied that there was any chasm gaping between God and man; he *lived* this unity of God and man, and that was precisely *his* "glad tidings"... And *not* as a special privilege! – From this time forward the type of the Saviour was corrupted, bit by bit, by the doctrine of Judgment and of the Second Coming, the doctrine of death as a sacrifice, the doctrine of the Resurrection, by which the entire concept of "blessedness", the whole and sole reality of the

Gospels, is secreted away – in favour of existence *after* death!... St. Paul, with that rabbinical impudence which showed itself in all his actions, rationalized this conception, this *obscene* conception, thus: "*If* Christ did not rise from the dead, then all our faith is in vain!" – And at once there sprang from the Gospels that most contemptible of all unfulfillable promises, the *shameless* doctrine of immortality... Paul even preached it as a *reward*!...

42.

One now begins to see *what* it was that came to an end with the death on the Cross: a new and primary genesis of a Buddhistic peace movement, an actual *happiness on Earth* – real, *not* merely promised. For this remains – as I have already pointed out – the essential difference between the two religions of *decadence*: Buddhism promises nothing, but delivers everything; Christianity promises everything, but *delivers nothing*. – Hard on the heels of the "glad tidings" came the *worst imaginable*: those of Paul. In Paul was embodied the very antithesis of the "bearer of glad tidings"; he represented the genius for hatred, the vision of hatred, the inexorable logic of hatred. *What*, indeed, has this anti-angel not sacrificed to hatred! Above all, the Saviour: he nailed him to *his* Cross. The life, the example, the teaching, the death of Christ, the meaning and the law of the whole Gospels – nothing was left once that hate-raddled counterfeiter had used it for his own ends. *Not* reality; *not* historical truth!... Once more the priestly instinct of the Jew perpetrated the same master crime against history – it simply erased the yesterday and the day before yesterday of Christianity, and invented its own *history of primitive Christianity.* More: it falsified the history of Israel yet again, so that it became a mere prologue to *its* achievement: all the prophets had

spoken of its "Saviour.".... Later on the Church even falsified the history of mankind in order to make it a prologue to Christianity... The figure of the Saviour, his teaching, his way of life, his death, the meaning of his death, even the aftermath of his death – nothing remained untouched, nothing was left even remotely resembling reality. Paul simply shifted the *centre of gravity of that whole life* to a place beyond this existence – in the lie of the "resurrected" Jesus. Basically, he had no use for the life of the Saviour – what he needed was the death on the Cross, *and* something more. To see anything honest in such a man as Paul, whose home was at the centre of Stoic enlightenment, when he *converts a hallucination* into proof of the *resurrection* of the Saviour, or even to believe his tale that he *suffered this hallucination* – this would be a genuine *niaiserie* on the part of a psychologist. Paul willed the end; *therefore* he also willed the means... What he himself did not believe was swallowed readily enough by the idiots among whom he spread *his* teaching. – What *he* sought was *power*; in Paul the priest once more lusted for power – he had use only for those concepts, teachings and symbols that served the purpose of tyrannizing the masses and fomenting mobs. *What* was the only part of Christianity that Mohammed would borrow later on? Paul's invention, his means of imposing priestly tyranny and firing up the mob: the belief in the immortality of the soul – *that is to say, the doctrine of "Judgment"*.

<div style="text-align:center">43.</div>

When the centre of gravity of life is taken *out* of life itself, and thrust into "the beyond" – into *nothingness* – then one takes away its centre of gravity altogether. The hideous lie of personal immortality destroys all reason, all natural instinct – henceforth, everything in the instincts that is salutary, that enhances life and that safeguards the

future becomes a reason for suspicion. *So to live that life no longer has any meaning: this* is now the 'meaning" of life... Why be public-spirited? Why take any pride in one's ancestry and forefathers? Why work together, trust one another, or worry about the common welfare, and try to serve it?... So many "temptations", so much straying from the "straight path". – *"One thing only* is necessary"... That every man, as an "immortal soul", is the equal of every other man; that in an infinite universe of things the "salvation" of *every* individual may lay claim to eternal importance; that insignificant bigots and the barely sane may imagine that the laws of nature are constantly *broken* on their behalf – it is impossible to lavish sufficient contempt upon such a magnification of every sort of puny ego to infinity, to *insolence*. And yet Christianity must thank precisely *this* pitiful flattery of personal vanity for its triumph – it was thus that it recruited all the crippled, the rebellious, the damned, the whole scum and trash of humanity to its ranks. The "salvation of the soul" – in plain words: "the world revolves around *me*"... The poisonous doctrine, *"equal* rights for all", has been propagated as a Christian principle: out of the secret sewers of basest instinct Christianity has waged a war to the death upon all feelings of reverence and distance between man and man, which is to say, upon the *prerequisite* of every step upward, to every development of civilization – out of the *resentment* of the masses it has forged its *chief weapon* against *us*, against everything noble, joyous and high-spirited on earth, against our happiness on earth... To allow "immortality" to every Peter and Paul was the most heinous, the most malicious outrage upon *noble* humanity ever committed. – *And* let us not underestimate the fatal influence that Christianity has had, even upon politics! Nowadays no-one has the courage to demand special rights or the right of rule, the courage to feel honourable pride in himself and his equals

– the courage for a *pathos of distance*... Our politics is *sick* with this lack of courage! – The aristocratic mindset has been undermined most profoundly by the lie of the equality of souls; and if belief in the "privileges of the majority" foments and *will continue to foment* revolutions – it is Christianity, let us not doubt, and Christian value judgements, which convert every revolution into a carnival of blood and crime! Christianity is a revolt by all creatures that crawl along the ground against everything that is *elevated*: the Gospel of the "lowly" renders them even lower...

<div align="center">44.</div>

– The Gospels are invaluable as evidence of the corruption that was already rife *within* the first community. What Paul, with the cynical logic of a rabbi, later carried to its conclusion was basically a process of decay that had commenced with the death of the Saviour. – These Gospels cannot be read too carefully; difficulties come with every word. I must confess – and I hope I will be forgiven – that it is precisely for this reason that they offer outstanding pleasure to a psychologist – as the *opposite* of all naive corruption, as refinement *par excellence,* as a masterpiece of psychological depravity. The Gospels, in fact, are in a class of their own. The Bible as a whole pales by comparison. Here we are among Jews: this is the *first* thing to bear in mind if we are not to lose the thread completely. This pure genius for conjuring up delusions of "holiness" is unmatched anywhere else, either in books or by men; this elevation of literary fraud and attitude to an *art* – all this is not an accident due to some individual talent, some violation of nature. The thing responsible is *race.* The whole of Judaism appears in Christianity as the art of perpetrating holy lies, and there, after many centuries of steadfast Jewish training and well-oiled

technique, attains its ultimate perfection. The Christian, that epitome of lying, is the Jew all over again – he is *threefold* the Jew... The underlying will to make use only of such concepts, symbols and attitudes that distinguishes priestly practice, the instinctive rejection of every *other* practice, and every *other* perspective in estimating values and applications – this is not just tradition, it is *inheritance:* only as an inheritance is it able to operate as a natural force. The whole of mankind, even the greatest minds of the finest ages (with one exception, who is barely human –), have allowed themselves to be deceived. The Gospels have been read as a *book of innocence..,* no small indication of the arch skill with which the fraud has been perpetrated. – Of course, if we could actually *see* these singular bigots and bogus saints, even if only for an instant, the charade would come to an end – and it is precisely because I cannot read a word of theirs without perceiving their attitude that I *have made an end of them...* I cannot endure the way they have of rolling up their eyes to Heaven. – For the majority of people, fortunately, books are mere literature. – Let us not be misled: they say "judge not", and yet they condemn to Hell anyone who stands in their way. By letting God sit in judgment, they judge themselves; by glorifying God they glorify themselves; by *demanding* that everyone display the same virtues which they themselves are capable of – indeed, which they must have in order to remain on top – they assume the grand air of men striving for virtue, of men engaging in a war in virtue's very name. "We live, we die, we sacrifice ourselves *for the good"* (– *"the* truth", "the light", "the kingdom of God"): in fact, they simply do what they cannot help doing. Forced, like hypocrites, to be sneaky, to skulk in corners, to slither along in the shadows, they convert this necessity into a *duty:* it is in the name of duty that they live their lives of humility, and that humility becomes merely one more proof of

their piety... Ah, that humble, chaste, compassionate brand of fraud! "Virtue itself shall bear witness for us.".... One may read the Gospels as books of *moral seduction:* these petty folks have fastened themselves to morality – they know its uses! Morality is the best tool for leading mankind *by the nose!* – The fact is that the conscious *arrogance of the chosen* here poses as modesty: it is in this way that *they,* the "community", the "good and just", range themselves, once and for always, on one side, the side of "the truth" – and the rest of mankind, "the world", on the other... *That* is surely the most fatal sort of megalomania that the earth has ever seen: little abortions of bigots and liars began to claim exclusive copyright in the concepts of "God", "the truth", "the light", "the spirit", "love", "wisdom" and "life", as if these were synonyms of themselves and they were thus fencing themselves off from the "world"; little super-Jews, ripe for the madhouse, twisted values upside down in order to suit *their own ends,* as if the Christian were the meaning, the salt, the standard and even the *last judge* of all the rest... The whole fatal disaster was only made possible by the fact that there already existed in the world a similar megalomania: the *Jewish* one: once a chasm began to open up between Jews and Judaeo-Christians, the latter had no choice but to employ the same methods of self-preservation that the Jewish instinct had devised *against* the Jews themselves, whereas the Jews had employed them only against *non*-Jews. The Christian is merely a Jew of the "reformed" confession. –

45.

– I offer here a few examples of the sort of thing these petty people have got into their heads – what they *have put into the mouth* of their Master: the immaculate credo of "beautiful souls". –

"And whosoever shall not receive you, nor hear you, when ye depart thence, shake off the dust under your feet for a testimony against them. Verily I say unto you, it shall be more tolerable for Sodom and Gomorrha in the day of judgment, than for that city" (Mark vi, 11) – How evangelical!

"And whosoever shall offend one of these little ones that believe in me, it is better for him that a millstone were hanged about his neck, and he were cast into the sea" (Mark ix, 42) . – How evangelical! –

"And if thine eye offend thee, pluck it out: it is better for thee to enter into the kingdom of God with one eye, than having two eyes to be cast into hell fire; Where the worm dieth not, and the fire is not quenched." (Mark ix, 47)15 – It is not exactly the eye that is meant...

"Verily I say unto you, That there be some of them that stand here, which shall not taste death, till they have seen the kingdom of God come with power." (Mark ix, 1.) – Well *lied*, lion!...

"Whosoever will come after me, let him deny himself, and take up his cross, and follow me. *For...*"
[*Observation of a psychologist*: Christian morality is refuted by its fors: its reasons are against it, –this makes it Christian.] (Mark viii, 34-5)
"Judge not, *that* ye be not judged. For with what measure ye mete, it shall be measured to *you* again." (Matthew vii, 1) – What a concept of justice, of a "just" judge!...

"For if ye love them which love you, *what reward have ye?* Do not even the publicans do the same? And if ye salute your brethren only, what do ye *more than others?* Do not even the publicans so?" (Matthew V, 46) – Principle of

"Christian love": it insists upon being well *paid*...

"But if ye forgive not men their trespasses, neither will your Father forgive your trespasses." (Matthew vi, 15) – Very compromising for the said "father".

"But seek ye first the kingdom of God, and his righteousness; and all these things shall be added unto you." (Matthew vi, 33) – All these things: namely, food, clothing, all the necessities of life. An *error*, to put it mildly... A little earlier this God appears as a tailor, at least in certain circumstances.

"Rejoice ye in that day, and leap for joy: *for*, behold, your reward is great in heaven: for in the like manner did their fathers unto the prophets." (Luke vi, 23) – Impudent rabble! It dares compare itself to the prophets

"Know ye not that ye are the temple of God, and that the spirit of God dwelleth in you? If any man defile the temple of God, *him shall God destroy*; for the temple of God is holy, *which temple ye are*." (1 Corinthians iii, 16) – Such notions are utterly beyond contempt...

"Do ye not know that the saints shall judge the world? And if the world shall be judged by *you*, are ye unworthy to judge the smallest matters?" (1 Corinthians vi, 2) – Unfortunately, not merely the ravings of a lunatic... This *frightful impostor* then continues: "Know ye not that we shall judge angels? How much more things that pertain to this life?"...

"Hath not God made foolish the wisdom of this world? For after that in the wisdom of God the world by wisdom knew not God, it pleased God by the foolishness of preaching to save them that believe...; not many wise

men after the flesh, not many mighty, not many noble are called: *But God hath chosen* the foolish things of the world to confound the wise; and God hath chosen the weak things of the world to confound the things which are mighty; and base things of the world, and things which are despised, hath God chosen, yea, and things which are not, to bring to nought things that are: That no flesh should glory in his presence." (1 Corinthians i, 20ff) – In order to *understand* this passage, a first rate example of the psychology underlying every Chandala-morality, one should read the first essay of my "Genealogy of Morals": there, for the first time, the antithetical relationship between a *noble* morality and a morality born of *resentment* and impotent vengefulness is plainly revealed. Paul was the greatest of all apostles of revenge...

<div align="center">46.</div>

– *What follows next?* That one should put on protective gloves before reading the New Testament. The presence of so much filth makes it extremely advisable. One would no more choose "early Christians" for companions as one would Polish Jews: not that one would need to prove a single point against them... Neither has a very pleasant smell. – I have searched the New Testament in vain for one single sympathetic trait; there is nothing free, kindly, open-hearted or upright in it. Humanity does not even take its first step upward – the instinct for *cleanliness is* lacking... Only *evil* instincts are there, and there is not even the courage to back up these evil instincts. It is all cowardice; it is all a shutting of the eyes, a self-deception. Every other book becomes clean, once one has read the New Testament: for example, immediately after reading Paul I took up with delight that most charming and wanton of mockers, Petronius, of whom one may repeat what Domenico Boccaccio wrote of Caesar Borgia to the

Duke of Parma: "è tutto festo" – immortally healthy, immortally cheerful and sound... For these petty bigots make a major miscalculation. They attack, but everything they attack is thereby *distinguished*. Whoever is attacked by an "early Christian" is surely *not* besmirched... On the contrary, it is an honour to have an "early Christian" as an opponent. It is impossible to read the New Testament without feeling admiration for whatever it abuses – not to mention the "wisdom of this world", which an impudent braggart tried vainly to dispose of... Even the Scribes and Pharisees are benefitted by such opposition: for they must certainly have been worth something to have been hated in such an indecent fashion. Hypocrisy – what an outrageous accusation coming from the "early Christians" – After all, the Scribes and Pharisees were the privileged, and that was enough: the hatred of the Chandala needed no other excuse. The "early Christian" – and also, I fear, the "last Christian", *whom I may perhaps live to see* – is a rebel against all privilege by basest instinct – he lives and strives forever for "equal rights"... Strictly speaking, he has no alternative. When a man proposes to embody, in his own person, the "chosen of God" – or to be a "temple of God", or a "judge of the angels" – then every *other* criterion, whether based upon honesty, upon intellect, upon manliness and pride, or upon beauty and freedom of the heart, becomes simply "worldly" – *manifest evil*... Moral: every word that comes from the lips of an "early Christian" is a lie, and his every act is instinctively dishonest – all his values, all his aims are noxious, but *whoever* he hates, *whatever* he hates, *has true value*... The Christian, and particularly the Christian priest, is thus *a criterion of values*.

– Must I add that, in the whole New Testament, there appears but *one* solitary figure worthy of honour? Pilate, the Roman governor. To regard a Jewish uprising *seriously*

– that was quite beyond him. One Jew more or less – what does it matter?... The noble scorn of a Roman, before whom the word "truth" was shamelessly abused, enriched the New Testament with the only saying that *has any value* – and that is at once its criticism and its *destruction:* "What is truth?"...

47.

– The thing that sets us apart is not that we are unable to find God, either in history, or in nature, or behind nature – but that we regard what has been honoured by others as God not as "divine", but as pitiable, as absurd, as pernicious; not merely an aberration, but as a *crime against life*... We deny that God is God... If anyone were to *prove* to us the existence of this Christian God, we would be even less inclined to believe in him. – In a formula: *Deus, qualem Paulus creavit, dei negatio.* – "God, as Paul created him, is a denial of God." – Such a religion as Christianity, which is not in touch with reality at any given point and which crumbles as soon as reality manifests itself, must be inevitably the mortal enemy of the "wisdom of this world", which is to say, of *science* – and it will approve of any means which serve to poison, vilify and *decry* all intellectual discipline, all lucidity and propriety in matters of intellectual conscience, all noble remove and freedom of the mind. "Faith," as an imperative, *vetoes* science – *in praxi*, lying at any price... Paul *understood* that mendacity – that "faith" – was necessary; later on the Church borrowed that fact from Paul. – The God that Paul invented for himself, a God who "reduces to absurdity" "the wisdom of the world" (especially the two great enemies of superstition, philology and medicine), is in truth only an indication of Paul's resolute *determination* to accomplish that very thing himself: to give one's own will the name of God, *Torah* –

that is quintessentially Jewish. Paul *wants* to confound the "wisdom of the world": his enemies are the *good* philologians and physicians of the Alexandrian school – on them he declares war. In fact, no man can be a philologian or a physician without being also *anti-Christian*. For a philologian sees *behind* the "holy books," and a physician sees *behind* the physiological depravity of the typical Christian. The physician says "incurable"; the philologian says "fraud."...

<div align="center">48.</div>

– Has anyone ever clearly understood the famous story at the beginning of the Bible – the story of God's mortal terror of *science?*... No-one, in fact, has understood it. This priest-book opens, as is fitting, with the great inner difficulty of the priest: *he* faces only *one* great danger; consequently, "God" faces only *one* great danger. –

The old God, wholly "spirit," wholly high-priest, wholly perfect, is strutting in his garden: but he is bored and trying to kill time. Against boredom even gods struggle in vain. So what does he do? He creates man – man is entertaining... But then he notices that man is also bored. God's sympathy with the only kind of distress that invades all paradises knows no bounds: so he immediately creates other animals. God's *first* mistake: to man, these other animals were not entertaining – in fact, he sought dominion over them; he did not want to be an "animal" himself. – So God created woman. Thus he brought boredom to an end but also sparked many other things! Woman was the *second* mistake of God. – "Woman, essentially, is a serpent, Heva" – every priest knows that; "from woman *every* evil springs into the world" – every priest knows that, too. *Consequently,* she is also to blame for *science*... It was through woman that

man learned to taste the fruit of the tree of knowledge. – What had happened? The old God was gripped by mortal terror. Man himself had been his *greatest* blunder; he had created a rival to himself; science makes men *equal to God* – it is all over with priests and gods when man becomes scientific! *Moral:* science is the forbidden in itself; it alone is forbidden. Science is the *primary* sin, the germ of all sins, the *original* sin. This *alone constitutes morality.* – "Thou shalt *not* know" – the rest follows on from that. – God's mortal terror, however, did not stop him from being shrewd. How can one *defend* oneself against science? For a long while this was his over-riding problem. Answer: banish man from Paradise! Happiness, leisure, foster thought – and all thoughts are bad! – Man *must* not think. – And so the "high priest" invents distress, death, the mortal dangers of childbirth, all sorts of misery, old age, decrepitude, above all, *sickness* – nothing but instruments for waging war on science! The troubles of man do not *allow* him to think... But nevertheless – how terrible! – the edifice of knowledge begins to tower up, penetrating the heavens, over-shadowing the gods – what can be done? – The old God invents *war;* he divides nations; he makes men destroy one another (the priests have always had need of war). War – among other things, a great disrupter of science! Incredible! Knowledge, *deliverance from the priests,* prospers in spite of war. – So the old God comes to his final resolution: "Man has become scientific – *there is nothing for it: he must be drowned!"*...

49.

– I hope I have been understood. The beginning of the Bible contains the *entire* psychology of the priest. – The priest knows of only *one* great danger: that is science – the sound comprehension of cause and effect. But science

flourishes, on the whole, only under favourable conditions – a man must have time, and an abundant intellect, in order to "know"... *"Therefore, man must be made unhappy,"* – this has been, throughout the ages, the logic of the priest. – It is easy to see just *what*, by this logic, was the first thing to come into the world: "sin"... The concept of guilt and punishment, the whole "moral world order", was invented *in opposition to* science – *against* the deliverance of man from priests... Man must *not* look outward; he must look only inward. He must *not* look at things wisely and cautiously, to learn about them; he must not look at all; he must *suffer*... And he must suffer so much that he is always in need of the priest. – Away with physicians! *What is needed is a Saviour.* – The concept of guilt and punishment, including the doctrines of "grace", of "salvation", of "forgiveness" – complete and utter *lies*, absolutely devoid of psychological reality were devised to destroy man's sense of *causality*: they are a savage attack upon the concept of cause and effect! – But *not* an attack with the fist, with the knife, with honest hate and love! On the contrary, an attack inspired by the most cowardly, the most cunning, the most ignoble of instincts! An *attack by priests!* An *attack by parasites!* A bloody, vampiric onslaught by pale, subterranean leeches!... When the natural consequences of an action are no longer "natural", but are regarded as being produced by the ghostly creations of superstition – by "God", by "spirits", by "souls" – and valued as merely "moral" consequences, as rewards, as punishments, as portents, as lessons, then the whole foundations of knowledge are destroyed – *then the greatest of all crimes against humanity has been perpetrated.* – I repeat that sin, man's self-violation *par excellence,* was invented purely in order to make science, culture, and every elevation and ennobling of man impossible; the priest *rules* by the invention of sin.

50.

– At this point I cannot permit myself to omit a psychology of "belief", of the "believer," for the special benefit of "believers" themselves. If there remain any today who do not yet know how *indecent* it is to "believe" – or how much a sign of *decadence*, of a broken will to live – then they will know it well enough tomorrow. My voice reaches even the deaf. – It appears, unless I have been incorrectly informed, that there exists among Christians a sort of criterion of truth that is called "proof by power". "Belief makes blessed: *therefore* it is true." – One might object right here that blessedness is not proven, it is merely *promised*: it depends upon "belief" as a condition – one *shall* be blessed *because* one believes... But what of that *thing* that the priest promises to the believer, the wholly transcendental "beyond" – how is *that* to be proven? The alleged "proof by power", is actually no more than a belief that the effects which belief promises will not fail to appear. In a formula: "I believe that faith makes for blessedness – therefore, it must be true."... But this is as far as we may argue the point. This "therefore" would be absurdity itself as a criterion of truth. – But let us admit, for the sake of indulgence, that blessedness by belief may be proven (– *not* merely desired, and *not* merely promised by the deceitful lips of a priest): even so, could blessedness – in a technical term, *pleasure* – ever be a proof of truth? So little is this true that it is almost a proof *against* truth when sensations of pleasure influence the answer to the question "What is true?" – or, at any rate, it is enough to make that "truth" highly suspicious. The proof by "pleasure" is a proof *of* pleasure – nothing more; why in the world should it be assumed that *true* judgments give more pleasure than false ones, and that in accordance with some preordained harmony, they necessarily bring agreeable feelings in their wake? – The

experience of all disciplined and profound intellect teaches *the contrary*. Man has had to fight for every grain of the truth, and has had to pay for it with almost everything that the heart, that human love, that human trust hold dear. Greatness of soul is needed for it: the service of truth is the hardest of all services. – What, then, is the meaning of *honesty* in things intellectual? It means that a man must be stern with his own heart, that he must spurn "beautiful feelings", and that he makes every Yes and No a matter of conscience! – Belief makes blessed: *therefore*, it lies

<p style="text-align:center">51.</p>

The fact that faith, under certain circumstances, may induce blessedness, but that this blessedness produced by an *idée fixe* by no means makes the idea itself true, and the fact that faith actually moves no mountains, but instead *places* them where there were none before: all this can be made abundantly clear by a fleeting visit to a *lunatic asylum. Not,* of course, to a priest: for his instincts compel him to pretend that sickness is not sickness and lunatic asylums not lunatic asylums. Christianity *needs* sickness, just as the Greek ethos demanded a superabundance of health – the true ulterior purpose of the whole system of salvation of the church is to *make* people sick. And the Church itself – does it not present the Catholic lunatic asylum as an ultimate ideal? – The whole earth as a madhouse? – The sort of religious man that the Church *desires* is a typical *decadent;* the moment when a religious crisis dominates a nation is always marked by epidemics of neurosis; the "inner world" of the religious man is so much like the "inner world" of the over-exerted and exhausted that it is difficult to distinguish between them; the "highest" states of mind held up before mankind by Christianity as of supreme value, are actually forms of

convulsive epilepsy – the Church has canonised only lunatics or arch frauds to the greater honour of God... Once, I ventured to designate the whole Christian system of training in penance and redemption (which can be now best studied in England) as a method of breeding a concentric insanity upon a soil already prepared for it, which is to say, a soil which is utterly pestilential. Not everyone is free to become a Christian: one is not "converted" to Christianity – one must bear a congenital sickness for itWe others, who have the *courage* for health *and* for contempt, – *we* may well despise a religion that teaches misunderstanding of the body! that refuses to rid itself of superstitions about the soul! that makes a "virtue" of eating too little! that combats health as a sort of enemy, devil, or temptation! that has persuaded itself that it is possible to bear a "perfect soul" in a virtual cadaver of a body, and so has had to devise for itself a new concept of "perfection", a pale, sickly, idiotically ecstatic state of existence, so-called "holiness" – a holiness that is itself merely a syndrome of symptoms of an impoverished, enervated and incurably corrupted body!... The Christian movement, as a European movement, was from the very start no more than a collective uprising every kind of outcast and scum (– who now, under the guise of Christianity, aspire to power) – It does *not* represent the decay of a race; it represents, on the contrary, a filthy conglomeration of *decadents* from all directions, herding together and seeking one another out. It was *not,* as generally believed, the corruption of antiquity, of *noble* antiquity, which made Christianity possible; one cannot too strongly challenge the learned imbecility which today maintains such a theory. In the period when the sick and rotten Chandala classes in the whole empire were Christianized, the *opposite* type, the nobility, reached its finest and ripest form. The majority became master; democracy, with its Christian instincts,

conquered... Christianity was not "national," it was not based on race – it appealed to all kinds of men disinherited by life, it had its supporters everywhere. Christianity has the bile of the sick at its very core – the instinct *hostile* to the healthy, to health itself. Everything that is well-constituted, proud, gallant and, above all, beautiful offends its ears and eyes. Again I remind you of Paul's priceless saying: "And God hath chosen the *weak* things of the world, the *foolish* things of the world, the *base* things of the world, and things which are *despised"*: *this* was the formula; by this credo *decadence* triumphed. – *God on the cross* – is man always to miss the frightful occult significance of this symbol? – Everything that suffers, everything that hangs on the cross, is *divine...* We all hang on the cross, so consequently *we* are divine... We alone are divine... Christianity was thus a victory: a *nobler* attitude of mind was destroyed by it – Christianity remains to this day the greatest calamity to befall humanity. –

52.

Christianity also stands in opposition to all *intellectual* well-being, – sick reason is the only sort that it *can* use as Christian propaganda; it takes the side of everything that is idiotic; it scars a curse upon "intellect", upon the rigours of the healthy intellect. Since sickness is inherent in Christianity, it follows that the typically Christian state of "faith" *must* be a form of sickness too, and that all honest, straightforward and scientific paths to knowledge *must* be banned by the Church as *forbidden*. Even doubt is thus a sin... The complete lack of psychological rectitude in the priest – evident from a mere glance at him – is a phenomenon resulting from decadence, – one may observe in hysterical women and in crippled children how regularly false instincts, delight in lying for the sake

of lying, and the inability to look straight or walk straight, are symptoms of *decadence*. "Faith" means the will to *avoid* at all cost knowing what is true. The pietist, the priest of either sex, is a fraud *because* he is sick: his instinct *demands* that the truth shall never be allowed to prevail in any way. "Whatever inflicts sickness is *good*; whatever issues from abundance, from excess, from power, is *evil*": so argues the believer. *The compulsion to lie* – by this trait I can recognize every pre-ordained theologian. Another sure sign of the theologian is his *incapacity for philology*. What I here mean by philology is, in a general sense, the art of reading well – the capacity for absorbing facts *without* interpreting them falsely, and *without* losing caution, patience and subtlety in the desire to understand them. Philology as indecision in interpretation: whether one be dealing with books, with newspaper reports, with the most fateful events or with weather statistics – not to mention the "salvation of the soul"... The way in which a theologian, whether in Berlin or in Rome, interprets a "passage of Scripture", for example, or an experience, or a victory by the national army, by scrutinising under the glaring spotlight of the Psalms of David, is always so *audacious* that it is enough to make a philologian crack his head against the wall. But what can he do when pietists and other such cows from Swabia use the "finger of God" to convert their miserably commonplace and drab existence into a miracle of "grace", of "providence" and of "experience of salvation"? Even the slightest exertion of the intellect, not to say of *decency*, should certainly be enough to convince these interpreters of the perfect childishness and unworthiness of such a misuse of divine dexterity. However minimal our piety, if we ever encountered a God who always cured us of a head cold in the head, or got us into our carriage at the very instant heavy rain began to fall, he would be such an absurd a God that he would have to be abolished even if he

existed. God as a domestic servant, as a postman, as an almanac-maker – basically, a byword for the most stupid sort of *chance occurrence*... "Divine Providence", which every third man in "educated Germany" still believes in, is in fact so strong an argument *against* God that it would be impossible to think of one stronger. And in any case it is an argument against the Germans!...

53.

– It is so untrue that *martyrs* offer any support to the truth of a cause that I am inclined to deny that a martyr has ever had anything to do with the truth at all. In the very tone in which a martyr hurls what he thinks to be true at the head of the world there appears so low a degree of intellectual integrity and such *insensibility* to the question of "truth", that it is never necessary to even refute him. Truth is not something that one man can possess and another man cannot: at best, only peasants, or peasant apostles like Luther, can think of truth in such a way. One may rest assured that the greater the degree of a man's intellectual conscience the greater will be his modesty, his *moderation,* on this point. To *know* five things, and to refuse, with delicacy, to know anything *else* ... "Truth", as the word is understood by every prophet, every sectarian, every free-thinker, every Socialist and every Churchman, is simply conclusive proof that not even a start has been made in the intellectual discipline and self-control that are necessary to the unearthing of even the smallest fact. – The deaths of the martyrs, it may be said in passing, have been the misfortunes of history: they have *seduced*... The conclusion that all idiots, women and nations come to, that there must be something in a cause for which anyone is willing to die (or which, like primitive Christianity, triggers epidemics of death-seeking) – this conclusion has been an unspeakable burden upon the

testing of facts, upon the whole spirit of inquiry and investigation. Martyrs have *damaged* the truth... Even to this day a crude sort of persecution is enough to give an *honourable* name to the most empty sort of sectarianism. – But why? Is the worth of a cause enhanced by the fact that someone had laid down his life for it? – An error that becomes honourable is simply an error that has acquired one seductive charm more: do you suppose, Theologians, that we shall give you the chance to be martyred for your lies? – One best refutes a cause by respectfully putting it on ice – that is also the best way to dispose of theologians... This was precisely the world-historical stupidity of all persecutors: that they gave the appearance of honour to the cause they opposed – that they bestowed upon it the fascination of martyrdom... Women are still on their knees before an error because they have been told that someone died on the cross for it. *Is the cross, then, an argument?* – But about all these things there is one, and one only, who has said what has been needed for thousands of years – *Zarathustra.*

They made sigils in blood along the path that they pursued, and their folly taught them that the truth is proved by blood.

But blood is the worst of all testimonies to the truth; blood poisons even the purest teaching and turns it into madness and hatred in the heart.

And when one walks through fire for his teaching – what does that really prove? In truth, it is more when one's teaching comes out of one's own burning!

54.

One must never be deceived: great intellects are always sceptical. Zarathustra is a sceptic. The strength, the

freedom which proceed from intellectual power, from a superabundance of intellectual power, *manifest* themselves as scepticism. Men of fixed convictions do not count when it comes to determining what is fundamental in values and lack of values. Men of convictions are prisoners. They do not see far enough, they do not see what is *below* them: whereas a man who would talk to any purpose about value and non-value must be able to see five hundred convictions *beneath* him – and *behind* him... A mind that aspires to great things, and that wills the means for greatness, is necessarily sceptical. Freedom from any sort of conviction *pertains* to strength, and to an independent point of view... That grand passion which is at once the foundation and the power of a sceptic's existence, and is both more enlightened and more despotic than he is himself, drafts the whole of his intellect into its service; it makes him fearless; it gives him courage to employ unholy means; under certain circumstances it even *permits* him even convictions. Conviction as a *means*: one may achieve a good deal by means of a conviction. Grand passion makes use of and uses up convictions; it does not yield to them – it knows itself to be sovereign. – Conversely, the need for belief, of some thing unconditioned by yes or no, of Carlylism if I may be allowed the expression, is a need of weakness. The man of faith, the "believer" of any sort, is necessarily a dependent man – such a man cannot posit himself as an ends, nor can he find ends within himself. The "believer" does not belong to *himself*, he can only be a means to an end; he must be *used*; he needs someone to use him. His instinct accords the highest honours to an ethic of self-effacement; he is prompted to embrace it by everything: his judgement, his experience, his vanity. Every sort of faith is in itself an evidence of self-effacement, of self-alienation... When one reflects how necessary it is to the great majority that they have

external regulations to restrain them and hold them fast, and to what extent control, or, in a higher sense, *slavery*, is the one and only condition which makes for the well-being of the weak-willed man, and especially woman, then one understands both conviction and "faith". To the man with convictions these are his backbone. To *avoid* seeing many things, to be impartial about nothing, to be a party man through and through, to estimate all values strictly and infallibly – these are conditions necessary to the existence of such a man. But he is therefore the antithesis of the truthful man – of the truth... The believer is not free to answer the question, "true" or "not true", according to the dictates of his own conscience: integrity on this point would mean his immediate destruction. The pathological limitations of his vision turn the man of convictions into a fanatic – Savonarola, Luther, Rousseau, Robespierre, Saint-Simon – these are opposites to the strong, emancipated spirit. But the grandiose attitudes of these sick intellects, these conceptual epileptics, are of influence upon the great masses – fanatics are picturesque, and mankind prefers to see poses rather than listen to *reason*...

<div align="center">55.</div>

– One step further in the psychology of conviction, of "belief". It is now a good while since I first proposed that convictions are even more dangerous enemies to truth than lies. This time I desire to put the question definitively: is there any actual difference between a lie and a conviction? – All the world believes that there is; but then what is *not* believed by all the world! – Every conviction has its history, its primal forms, its tentative shape and errors: it *becomes* a conviction only after having been, for a long time, *not* one at all, and then, for an even longer time, *hardly* one. What if falsehood could be also

one of these embryonic forms of conviction? – Sometimes all that is needed is a change in persons: what was a lie in the father becomes a conviction in the son. – I call it lying to *refuse* to see what one sees, to refuse to see it *as* one sees it: whether the lie be uttered in front of witnesses or not is of no consequence. The most common sort of lie is that by which a man deceives himself: the deception of others is a relatively rare offence. – Now, this desire *not* to see what one sees, this will not to see as one sees, is almost the first prerequisite for all who belong to a *party* of whatever sort: the party man inevitably becomes a liar. For example, German historians are convinced that Rome was synonymous with despotism and that the Germanic peoples brought the spirit of liberty into the world: what is the difference between this conviction and a lie? Is it to be wondered at that all partisans, including German historians, instinctively roll the fine phrases of morality upon their tongues – that morality *continues to exist* due to the fact that the party man of every sort has need of it every moment? – "This is *our* conviction: we declare it to the whole world; we live and die for it – let us respect all who have convictions!" – I have actually heard such sentiments from the mouths of anti-Semites. On the contrary, gentlemen! An anti-Semite surely does not become more respectable because he lies on principle... The priests, who have more finesse in such matters, and who well understand the objection that lies against the notion of a conviction, which is to say, of a falsehood that becomes a matter of principle *because* it serves a purpose, have borrowed from the Jews the shrewd device of sneaking in the concepts, "God", "the will of God" and "the revelation of God" in its place. Kant, too, with his categorical imperative, was on the same road: this was his *practical* reason. There are questions regarding truth or untruth which *cannot* be decided by man; all the supreme questions, all the supreme problems of valuation, are

beyond human reason... To know the limits of reason – that alone is genuine philosophy. Why did God make a revelation to man? Would God have done anything superfluous? Man *could not* find out for himself what was good and what was evil, so God taught him His will. Moral: the priest does *not* lie – the question, "true" or "untrue", does not *arise* in such things as the priest discusses; it is impossible to lie about these things. In order to lie here it would be necessary to know *what* is true. But this is more than man *can* know; therefore, the priest is the only mouth-piece of God. – Such a priestly syllogism is by no means merely Jewish and Christian; the right to *lie* and the shrewdness of "revelation" belong to the general priestly type – to the priest of *decadence* as well as to the priest of paganism (– Pagans are all those who say yes to life, and to whom "God" is a word signifying acquiescence in all things) – The "law", the "will of God", the "holy book", and "inspiration" – all these things are merely words for the conditions *under* which the priest comes to power and *with* which he maintains his power, – these concepts are to be found at the basis of all priestly organizations, and of all priestly or priestly-philosophical power hierarchies. The "holy lie" – common alike to Confucius, to the Code of Manu, to Mohammed and to the Christian Church – is not even lacking in Plato. "Truth is here": this means, no matter where it is heard, *the priest is a liar...*

56.

– In the final analysis it comes to this: what is the *point* of lying? The fact that, in Christianity, "holy" ends are lacking is my objection to the means it employs. Only *bad* ends are evident: the poisoning, the slandering, the denial of life, the contempt for the body, the degradation and self-contamination of man by the concept of sin –

consequently, its means are also bad. – I have a contrary feeling when I read the Code of Manu, an incomparably more intellectual and superior work, which it would be a sin against the intelligence to so much as name in the same breath as the Bible. It is easy to see why: there is a genuine philosophy behind it, *in* it, not merely an evil-smelling mess of Jewish rabbinism and superstition, – it gives even the most fastidious psychologist something to sink his teeth into. And, not to forget what is most important, it differs fundamentally from every kind of Bible: by means of it the *nobles*, the philosophers and the warriors keep the whip-hand over the herd; it is full of noble valuations, it shows a feeling of perfection, an affirmation of life, and triumphant feeling toward self and life – the *sun* shines upon the whole book. – All the things on which Christianity vents its abysmal vulgarity – for example, procreation, women and marriage – are here handled earnestly, with reverence and with love and trust. How can any one really put into the hands of children and ladies a book which contains such vile things as this: "to avoid fornication, let every man have his own wife, and let every woman have her own husband;... for it is better to marry than to burn"? And is it *possible* to be a Christian so long as the origin of man is Christianized, which is to say, *soiled,* by the doctrine of the immaculate conception? I know of no book in which so many delicate and tender things are said of women as in the Code of Manu; these old grey-beards and saints have a way of being gallant to women that it would be impossible, perhaps, to surpass. "The mouth of a woman," it says in one place, "the breasts of a girl, the prayer of a child and the smoke of sacrifice are always pure." In another passage: "there is nothing purer than the light of the sun, the shadow cast by a cow, air, water, fire and a girl's breath." Finally, in still another place – perhaps this is also a holy lie – : "all the orifices of the

body above the navel are pure, and all below are impure. Only in the case of a girl is the whole body pure."

57.

One catches the *unholiness* of Christian means *in flagrante* by the simple process of comparing the ends sought by *Christianity* to the ends sought by the Code of Manu – by shining a strong light on their vastly antithetical purposes. The critic of Christianity cannot evade the necessity of revealing Christianity to be utterly *contemptible*. – A book of laws such as the Code of Manu has the same origin as every other good law-book: it summarizes the experience, the wisdom and the ethical experimentation of long centuries; it brings things to a conclusion; it creates nothing new. The prerequisite to a codification of this sort is recognition of the fact that the means which establish the authority of a slowly and painfully attained *truth* are fundamentally different from those with which one would demonstrate it. A law-book never explains the utility, the grounds, the casuistic antecedents of a law: for if it did so it would lose the imperative tone, the "thou shalt", on which obedience is predicated. The problem lies precisely here. – At a certain point in the evolution of a people, its most enlightened, which is to say, those with the the greatest hindsight and foresight, declare that the series of experiences determining how all shall live – or *can* live – has come to a fixed end. Their object now is to reap as rich and as complete a harvest as possible from the days of experiment and *hard* experience. Consequently, the thing that is to be avoided above everything is further experimentation – the continuation of the state in which values are fluid, and are tested, chosen and criticized *ad infinitum*. Against this a two-fold barrier is set up: on the one hand, *revelation*, which is the assumption that the

reasons lying behind the laws are *not* of human origin, that they were *not* sought out and found by a slow process and after many errors, but that they are of divine origin, and came into being complete, perfect, without a history, as a gift, a miracle; and on the other hand, *tradition,* which is the assertion that the law has stood unchanged from time immemorial, and that it would be impious and a crime against one's forefathers to call it into question. The authority of the law is thus grounded on the thesis: God *gave* it, and the forefathers *lived* it. – The higher motive of such procedure lies in the design to distract consciousness, step by step, from its concern with notions of correct living (that is to say, those that have been *proved* to be right by wide and carefully considered experience), so that instinct achieves a perfect automatism – a primary necessity for every sort of mastery, for every sort of perfection in the art of living. To draw up such a lawbook as Manu's means to lay before a people the possibility of future mastery, of attainable perfection to aspire to the highest art of life. *To that end the law must be made unconscious*: that is the aim of every holy lie. – The *order of castes*, the supreme, the dominating law, is merely the sanctioning of a *natural order*, of a natural law of the first rank, over which no arbitrary caprice, no "modern idea", can exert any power. In every healthy society there are three physiological types, gravitating toward differentiation but mutually conditioning one another, and each of these has its own hygiene, its own sphere of work, its own special mastery and feeling of perfection. It is *not* Manu but nature that separates those who are chiefly intellectual, those who are marked by muscular strength and temperament, and those who are distinguished in neither one way or the other, but show only mediocrity – the latter representing the great majority, and the first two the elite. The superior caste – I call it *the chosen few* – has, as the most perfect, the

privileges of the few: it stands for happiness, for beauty, for everything good upon earth. Only the most intellectual of men have any right to beauty, to beautiful things; only in them can benevolence escape being weakness. *Pulchrum est paucorum hominum*: goodness is a privilege. Nothing could be more distasteful to them than uncouth manners or a pessimistic look, or an eye that *sees ugliness* – or indignation against the collective aspect of things. Indignation is the privilege of the Chandala; so is pessimism. *"The world is perfect"* – so prompts the instinct of the intellectual, the instinct of the man who says yes to life. "Imperfection, whatever is *inferior* to us, distance, the pathos of distance, even the Chandala themselves are parts of this perfection." The most intelligent men, like the *strongest,* find their happiness where others would find only destruction: in the labyrinth, in severity towards themselves and others, in striving; their delight is in self-mastery; in them asceticism becomes second nature, a need, an instinct. They regard a hard task as a privilege; it is to them a *recreation* to play with burdens that would crush all others... Knowledge – a form of asceticism. – They are the most venerable kind of men: but that does not prevent them being the most cheerful and most amiable. They rule, not because they want to, but because they *are*; they are not at liberty to play second. – The *second* caste: to this belong the guardians of the law, the keepers of order and security, the more noble warriors and, above all, the *king* as the highest form of warrior, judge and keeper of the law. The second in rank constitute the executive arm of the intellectuals, the next to them in rank, taking from them all that is *coarse* in the business of ruling – their followers, their right hand, their most ardent disciples. – In all this, I repeat, there is nothing arbitrary, nothing "made up"; whatever is *different* to this rank is artificial – and so nature is brought to shame... The order of castes, the *order of rank*, simply

formulates the supreme law of life itself; the separation of the three types is necessary to the preservation of society, and to the evolution of higher types, and the highest types – the *inequality* of rights is essential to the existence of any rights at all. – A right is a privilege. Everyone enjoys the privileges that accord with his state of existence. Let us not underestimate the privileges of the *mediocre*. Life is always harder as one mounts the *heights* – the cold increases, responsibility increases. A high civilization is a pyramid: it can stand only on a broad base; its primary prerequisite is a strong and soundly consolidated mediocrity. The handicrafts, commerce, agriculture, *science*, the greater part of art, in brief, the whole range of *occupational* activities, are compatible only with mediocre ability and aspiration; such callings would be out of place for exceptional men; the instincts which belong to them stand as much opposed to aristocracy as to anarchy. The fact that a man is publicly useful, that he is a wheel, a function, is a natural vocation; it is *not* society, but the only sort of *happiness* that the majority are capable of, that makes them intelligent machines. To the mediocre mediocrity is a form of happiness; they have a natural instinct for mastering one thing, for specialization. It would be altogether unworthy of a profound intellect to see anything objectionable to mediocrity in itself. It is, in fact, the prime prerequisite to the appearance of the exceptional: it is a necessary condition to a high degree of civilization. When the exceptional man handles the mediocre man with more delicate fingers than he applies to himself or to his equals, this is not merely kindness of heart – it is simply his *duty*... Whom do I hate most vehemently among the rabbles of today? The rabble of Socialists, the apostles to the Chandala, who undermine the working man's instincts, his pleasure, his feeling of contentment with his petty existence – who make him envious and teach him

revenge... Wrong never lies in unequal rights; it lies in the assertion of *"equal"* rights... What is *bad?* But I have already answered that question: all that proceeds from weakness, from envy, from revenge. – The anarchist and the Christian have a common ancestry...

58.

In point of fact, the end for which one lies makes a great difference: whether one preserves with a lie or *destroys.* There is a perfect likeness between *Christian* and *anarchist:* their purpose, their instinct, points only toward destruction. One need only turn to history for the proof of this: there it appears with appalling clarity. We have just studied a code of religious legislation whose object it was to convert the conditions which cause life to *flourish* into an "eternal" social organization, – Christianity found its mission in putting an end to such an organization, *because life flourished under it.* There the benefits that reason had produced during long ages of experiment and insecurity were applied to the most distant future, and an effort was made to bring in a harvest that should be as large, as rich and as complete as possible; here, on the contrary, the harvest is *blighted* overnight... That which stood there *aere perennis,* the Roman Empire, the most magnificent form of organization under adverse conditions, that has ever been sustained, and compared to which everything before it and after it appears as patchwork, bungling, dilletantism – those holy anarchists made it a matter of "piety" to destroy "the world", which is to say, the Roman Empire, so that in the end not a single stone stood upon another – and even Germans and other such barbarians were able to become its masters... The Christian and the anarchist: both are *decadents;* both are incapable of any act that is not dissolute, poisonous, degenerate, *blood-sucking;* both have an instinct of *mortal*

hatred of everything that stands up, and is great, and has durability, and promises life a future... Christianity was the vampire of the Roman Empire, – overnight it destroyed the vast achievement of the Romans: the conquest of the soil for a great culture *that could await its time.* Can it be that this fact is not yet understood? The Roman Empire that we know, and that the history of the Roman provinces allows us to know better and better, – this most admirable of all works of art in the grand style was merely the beginning, and the structure to follow was designed to *prove* its worth over thousands of years. To this day, nothing on a like scale sub *specie aeterni* has been created, or even dreamed of! – This organization was strong enough to endure bad emperors: the accident of personality has nothing to do with such things – the *first* principle of all genuinely great architecture. But it was not strong enough to stand up against the *corruptest* form of corruption – against Christians... These stealthy vermin, which under the cover of night, fog and duplicity, crept upon every individual, sucking him dry of all earnest interest in real things, of all instinct for *reality* – this cowardly, effeminate and honeyed gang gradually alienated all "souls", step by step, from that colossal edifice, turning against it all the precious, manly and noble natures that had found in the cause of Rome their own cause, their own seriousness of purpose, their own pride. The underhanded bigotry, the secrecy of the conventicle, such black concepts as Hell, as the sacrifice of the innocent, the sacred communion of the drinking of blood, above all, the slowly rekindled fire of revenge, of Chandala revenge – *that* sort of thing became master of Rome: the same kind of religion on which, in its pre-existent form, Epicurus had declared war. One has but to read Lucretius to know what Epicurus made war upon – not paganism, but "Christianity", which is to say, the corruption of souls by means of the concepts of guilt,

punishment and immortality. – He combatted the subterranean cults, the whole of latent Christianity – to deny immortality was already a form of genuine *salvation*. – Epicurus had triumphed, and every respectable intellect in Rome was Epicurean – *when Paul appeared*... Paul, Chandala hatred against Rome, of "the world", in the flesh and inspired by genius – the Jew, the *eternal* Jew *par excellence*... What he divined was how, with the aid of the small sectarian Christian movement that stood apart from Judaism, a "world conflagration" might be ignited; how, with the symbol of "God on the cross", all secret seditions, all the fruits of anarchistic revolts in the empire, might be amalgamated into one immense power. "Salvation is of the Jews." – Christianity as the formula for exceeding *and* summing up the subterranean cults of all varieties, that of Osiris, that of the Great Mother, that of Mithras, for example: in his grasping of this fact the genius of Paul revealed itself. His instinct was here so sure that, with ruthless violence to the truth, he put the ideas which lent fascination to every sort of Chandala religion into the mouth of the "Saviour" as his own inventions, and not only into the mouth – he made out of him something that even a priest of Mithras could understand... This was his revelation on the road to Damascus: he grasped the fact that he needed the belief in immortality in order to rob "the world" of its value, that the concept of "Hell" would master even Rome – that the notion of a "beyond" is the death of life. Nihilist and Christian: they rhyme in German, and they do much more than rhyme...

59.

The whole labour of the ancient world gone *in vain*: I have no word to describe the feelings that such an dreadful calamity arouses in me. – And, considering the

fact that its labour was merely preparatory, that with adamantine self-consciousness it laid only the foundations for a work to go on for thousands of years, the whole *meaning* of antiquity disappears!... Why did the Greeks exist? Why the Romans? – All the prerequisites to a learned culture, all the *methods* of science, were already there; man had already perfected the great and incomparable art of reading well – that first necessity to the tradition of culture, the unity of the sciences; natural science, in alliance with mathematics and mechanics, was on the truest possible road, – the *sense for fact*, the last and most valuable of all the senses, had its schools, and its traditions were already centuries old! Is all this properly understood? Everything *essential* to the beginning of the work was in place; – and the most essential, it cannot be said too often, *are* methods, and also the most difficult to develop, and the longest opposed by habit and laziness. What we have today reconquered, with unspeakable self-discipline, for ourselves – for certain bad instincts, that is to say certain Christian instincts, still lurk within us – the keen eye for reality, the cautious hand, patience and seriousness in the smallest things, the whole *integrity* of knowledge – all these things were already there, and had been there for two thousand years! *More*, there was also a refined and excellent tact and taste! And *not* as mere brainwashing! Not as "German" culture, with its brutish manners! But as body, as bearing, as instinct – in short, as reality... *All gone in vain*! Overnight it became merely a memory! – The Greeks! The Romans! Instinctive nobility, taste, methodical inquiry, genius for organization and administration, faith in and the will to secure the future of man, the great Yes to everything entering into the Roman Empire and palpable to all the senses, a grand style that was beyond mere art, but had become reality, truth, *life*... – All overwhelmed in a night, but not by a convulsion of nature! Not trampled to death

by Teutons and others of heavy hoof! But brought to shame by crafty, secretive, invisible, anaemic vampires! Not conquered, – only sucked dry!... Hidden vengefulness, petty envy, became *master*! Everything wretched, intrinsically ailing, and twisted by bad feelings, the whole *ghetto-world* of the soul, was suddenly *on top*! – One needs only read any of the Christian agitators, for example, St. Augustine, in order to realize, in order to *smell,* what filthy scum rose to the top. It would be an error, however, to assume that there was any lack of intelligence in the leaders of the Christian movement: – ah, but they were clever, clever to the point of holiness, these fathers of the Church! What they lacked was something quite different. Nature neglected – perhaps forgot – to give them even the most modest endowment of respectable, of upright, of *cleanly* instincts... Between ourselves, they are not even men... If Islam despises Christianity, it has a thousandfold right to do so: Islam at least assumes that it is dealing with *men...*

60.

Christianity destroyed for us the whole harvest of ancient civilization, and later it also destroyed for us the whole harvest of *Islamic* civilization. The wonderful culture of the Moors in Spain, which was fundamentally nearer to us and appealed more to our senses and tastes than that of Rome and Greece, was *trampled down* (– I do not say by what sort of feet –) Why? Because it had to thank noble and manly instincts for its origin – because it said yes to life, even to the rare and refined luxuriousness of Moorish life!... The Crusaders later made war on something before which it would have been more fitting for them to have grovelled in the dust – a civilization beside which even that of our nineteenth century seems very poor and very "senile'. – What they wanted, of course, was booty: the

Orient was rich... But let us put aside our prejudices! The Crusades were a higher form of piracy, nothing more! The German nobility, which is fundamentally a Viking nobility, was in its element there: the Church knew only too well how the German nobility could be *bought*... The German noble, always the "Swiss guard" of the Church, always in the service of every bad instinct of the church – but *well paid*... Consider the fact that it is precisely the aid of German swords and German blood and valour that has enabled the Church to carry on its deadly war upon everything noble on earth! At this point a host of painful questions arise. The German nobility stands *outside* the history of the higher civilizations: the reason is obvious... Christianity, alcohol – the two *great* means of corruption... Intrinsically there should be no more choice between Islam and Christianity than there is between an Arab and a Jew. The decision is already reached; nobody remains at liberty to choose here. Either a man is a Chandala or he is *not*... "War to the knife with Rome! Peace and friendship with Islam!": this was the feeling, this was the *act*, of that great free spirit, that genius among German emperors, Frederick II. What! must a German first be a genius, a free spirit, before he can feel *decently*? It escapes me how a German could ever feel *Christian*...

61.

Here it becomes necessary to call up a memory that must be a hundred times more painful to Germans. The Germans have destroyed for Europe the last great harvest of civilization that Europe was ever to reap – the *Renaissance*. Is it understood at last, will it ever be understood, *what* the Renaissance actually was? The *transvaluation of Christian values,* – an attempt with all available means, all instincts and all the resources of

genius to bring about a triumph of the opposite values, the more *noble* values... *This* has been the one great war of the past; there has never been a more critical question than that of the Renaissance – it is *my* question too -; there has never been a form of *attack* more fundamental, more direct, or more violently delivered by an entire front upon the centre of the enemy! To attack at the critical point, at the very seat of Christianity, and there enthrone the more *noble* values – that is to say, to insinuate them *into* the instincts, into the most fundamental needs and appetites of those sitting there... I see before me the *possibility* of a quite unearthly fascination and spectacle: – it seems to me to scintillate with all the vibrations of a fine and delicate beauty, and within it there is an art so divine, so infernally divine, that one might search in vain for thousands of years for another such possibility; I see a spectacle so rich in significance and at the same time so wonderfully full of paradox that it should arouse all the gods on Olympus to immortal laughter – *Caesar Borgia as Pope!*... Am I understood?... Well then, *that* would have been the sort of triumph that *I* alone am longing for today -: by it Christianity would have been *abolished*! – What happened? A German monk, Luther, came to Rome. This monk, with all the vindictive instincts of a failed priest in him, fomented a rebellion *against* the Renaissance in Rome... Instead of grasping, with profound thanksgiving, the miracle that had taken place: the conquest of Christianity at its *capital* – instead of this, his hatred was stimulated by the spectacle. The religious man thinks only of himself. Luther saw only the *corruption* of the papacy at the very moment when the opposite was becoming apparent: the old corruption, the *original sin,* Christianity itself, *no longer* occupied the papal chair! Instead there was life! Instead there was the triumph of life! Instead there was a great Yes to all lofty, beautiful and daring things!... And Luther *restored the*

Church: he attacked it... The Renaissance – an event without meaning, a great *futility*! – Ah, these Germans, what they have not cost us! Futility – that has always been the *work* of the Germans. – The Reformation; Liebnitz; Kant and so-called German philosophy; the war of "liberation"; the *Reich* – every time a futile substitute for something that once existed, for something *irretrievable*... These Germans, I confess, are *my* enemies: I despise all their uncleanliness in concept and valuation, their *cowardice* before every honest yes and no. For nearly a thousand years they have twisted and confused everything their hands have touched; they have on their conscience all the half-way measures, all the three-eighths-way measures, that Europe is sick of, – they also have on their conscience the uncleanest kind of Christianity that exists, and the most incurable and indestructible – Protestantism... If mankind never manages to get rid of Christianity, the Germans will be to blame...

62.

– With that I come to a conclusion and pronounce my judgment. I condemn Christianity; I bring against the Christian Church the most terrible of all the accusations that an accuser has ever uttered. It is, to me, the greatest of all imaginable corruptions; it seeks to work the ultimate corruption, the worst possible corruption. The Christian Church has left nothing untouched by its depravity; it has turned every value into worthlessness, and every truth into a lie, and every integrity into vileness of the soul. Let anyone dare to speak to me of its "humanitarian" blessings! Its deepest necessities range it against any effort to *abolish* distress; it lives *by* distress; it *creates* distress to make itself immortal... For example, the worm of sin: it was the Church that first enriched

mankind with this misery! The "equality of souls before God" – this fraud, this *pretext* for the revolts of all the base-minded – this explosive concept, ending in revolution, the modern idea, and the notion of overthrowing the whole social order – this is *Christian* dynamite... The "humanitarian" blessings of Christianity indeed! To breed out of humanity a self-contradiction, an art of self-violation, a will to lie at any price, an aversion and contempt for all good and honest instincts! All this, to me, is the 'humanitarianism" of Christianity! – Parasitism as the *sole* practice of the church; with its anaemic and "holy" ideals, sucking all the blood, all the love, all the hope out of life; the beyond as the will to deny all reality; the Cross as the distinguishing mark of the most subterranean conspiracy that ever existed, – against health, beauty, well-being, bravery, intellect, *kindness* of soul – *against life itself...*

This eternal accusation against Christianity I shall write upon all walls, wherever walls are to be found – I have letters that even the blind will be able to see... I call Christianity the *one* great curse, the *one* great intrinsic depravity, the *one* great instinct of revenge, for which no means are venomous enough, or secret, subterranean and *petty* enough, – I call it the *one* immortal blemish upon the human race...

And mankind reckons time from the fateful day when this fatality befell us – from the *first* day of Christianity! – *Why not rather from its last? – From today? –* The transvaluation of all values!...

PART TWO
FRAGMENTS
FROM A SHATTERING MIND

Spring 1888

Nihilism

Nothing would be more useful and deserving promotion than **resolute nihilism of action.**

: As I understand all phenomena of Christianity, of pessimism, they express, "we are ready not to be; it is reasonable for us not to be."

in this case this language of "reason" would also be the language of **selective nature.**

Yet what is to be condemned more than anything else, is the ambiguous and cowardly half-heartedness of a religion like **Christianity**: to be more explicit, the **Church**: which, instead of encouraging death and self-destruction, protects all sick and ill-begotten and makes it propagate (itself) –

Problem: which would be the ways of a strict form of the great contagious nihilism: one that teaches and practises voluntary death with scientific meticulousness... (and **not** the weak vegetating in expectation of a false post-existence–)

You cannot condemn Christianity enough because it has **devaluated** such a **purifying** great movement of nihilism, which has perhaps been in progress, with the idea of an immortal subject: likewise with the hope for resurrection: in short it has always prevented us from the **deed of nihilism**, suicide...It substituted slow suicide;

little by little a small and poor but lasting life; little by little an ordinary and mediocre bourgeois life etc.

Counter-Movement Art
The Birth of Tragedy

III

These two natural phenomena of art: are juxtaposed by Nietzsche as the Dionysic and the Apollinic: he claims that – the word "dionysic" expresses: an urge for unity, a reaching out beyond subject, everyday life, society, reality, as an abyss of oblivion, the passionate and painful swelling into darker, fuller and more suspended states; an ecstatic word of consent to the comprehensive nature of life as the unchanged, equally powerful and equally blissful in all transformation; the great pantheistic compassion and commiseration even sanctioning and holding sacred the most atrocious and problematic qualities of life, out of the eternal will to procreation , to fertility, to eternity: as a unifying feeling of the necessity of creation and annihilation... The word "apollinic" expresses: the yearning for being by oneself, for the typical "individual", for all that simplifies, emphasises, makes strong, lucid, unambiguous and typical: the freedom under the law.

The progression of art is as necessarily linked to them, as the evolution of mankind is linked to the antagonism of the sexes. The profusion of power and restraint, the highest form of self-affirmation in a breezy, distinguished and reserved beauty: the Apollinism of the Hellenic will –

The origin of tragedy and comedy as **immediately seeing** a divine type in the state of comprehensive ecstasy, as the experience of history, the visit, the miracle, the act of foundation, the "drama" –

This conflict of the Dionysic and the Apollinic

within the Hellenic soul is one of the great mysteries N[ietzsche] has been attracted by considering the Hellenic nature. Basically, Nietzsche only tried to guess, why exactly the Greek Apollinism had to grow out of a dionysic underground: the dionysic Greek had to become apollinic, which means: to break his will to the colossal, multiple, uncertain and atrocious with a will to restraint, simplicity, subordination to terms and rules. The measureless, the wild, the Oriental lies at its ground: the braveness of the Greek comes off victorious in its struggle with his Orientalism: Beauty is not given to him, nor are logic and naturalness of mores – they are conquered, wanted, fought for – they are his victory...

Birth of Tragedy.

2.

Beginning of the section two pages below: II.

Here art represents the only superior counterforce against all will to the negation of life: as the anti-Christian, anti-Buddhist, anti-nihilistic *par excellence*...

It is the **salvation of** a tragic figure; **the one who sees**, who wants to see the dreadful and problematic nature of life,

It is the **salvation of the one who acts** – the one who does not only see the dreadful and questionable nature of life, but lives it, **wants** to live it, the tragic man, the hero..

It is the **salvation of the suffering** – as a way to states of mind where suffering is welcomed, transfigured, idolized, where suffering is a form of the great ecstasy...

4.

In this respect this book is even anti-pessimistic: in the sense that it teaches something that is stronger than pessimism, more divine than "the truth": art.

As it seems, nobody would endorse a radical negation of life, even more a genuine active negation than saying no to life, like the author of this book: yet he knows, – he has experienced it, perhaps, he has not experienced anything else – that art is **more precious** than "the truth."

Already in the preface, a quasi-invitation to a dialogue with Richard Wagner on the profession of faith, the artist's gospel comes up: "**art** as the actual task of life, art as a **metaphysical pursuit**"...

II

The essential point in this conception is the notion of art in its relation to life: it is perceived, psychologically as well as physiologically, as the great **stimulant**, which urges to life eternally, to eternal life...

The Birth of Tragedy

But let us come to the main point, the aspect that distinguishes and accompanies the book, its originality: it contains three conceptions. We have already mentioned the first: art as the great stimulant of life, to life. The second: it comes up with a new type of pessimism; the **classic one**. Thirdly: it considers a psychological problem, the **Greek** one, in a new way.

Type "Jesus"

Jesus is the **opposite of a genius**: he is an **idiot**. Feel his inability to perceive reality: he circles around five or six terms he has heard of before and has understood with time, i.e. misunderstood – they represent his experience, his world, his truth, – the rest is foreign to him. He utters words everybody needs – he does not understand them like everybody else. He only understands his five, six spongy terms. That the real instincts of man – not only the sexual ones but also the ones of fight, pride, heroism

– have never awakened inside him, that he is retarded and, like a child, has stopped in his puberty: this belongs to the type of certain epilepsoid neuroses.

Jesus is unheroic in his deepest instincts: he never fights: who sees something like a hero in him, like Renan, has vulgarised the type past recognition.

Feel, on the other hand, his inability to understand intellectual things: the word intellect becomes a misconception in his mouth! Not a whiff of science, taste, intellectual discipline has blown at this holy idiot: as little as life has touched him. – Nature? Laws of nature? – Nobody has shown him that there is such a thing as nature. He only knows moral effects: a sign of the lowest and most absurd culture. You have to state: he is an idiot in the middle of a very shrewd people...yet his disciples were not – St. Paul was not at all an idiot! – the history of Christianity depends on that.

Counter-Movement of Art.
Pessimism in Art? –

With time the artist loves for their own sake the manifestations in which ecstasy declares itself: the extreme delicacy and splendour of colour, the distinctness of touch, the nuance of tone: the **distinct**, where elsewhere, in ordinariness all distinction is absent.

–: All distinct things, all nuances, inasmuch as they remind of the extreme increase of strength induced by ecstasy, evoke in reverse this feeling of ecstasy.

–: The effect of the work of art is **the stimulation of the aesthetically productive state of mind**, the ecstasy

–: The perfection of being remains the essential in art, its production of perfection and plenty
essentially, **art is affirmation, benediction, apotheosis of being**...

–: What does **pessimistic art** mean?.. Isn't this a

contradiction? – Yes.

Schopenhauer **errs** when he puts certain works of art in the service of pessimism. The tragedy does not teach "resignation"...

–The depiction of dreadful and problematic things is itself already the artist's instinct of power and grandeur: he does not fear them...

There is no pessimistic art...Art is affirmation. Job is affirmation.

But Zola? But de Goncourt?

–The things they show are ugly: but that they show them is out **of lust for these ugly things** ...

–Like it or not! You cheat yourselves, if you claim something else

How redeeming is Dostoyevsky!

Will to Power as Art
"Music" – and the Great Style

The greatness of an artist is not measured along the lines of the "beautiful feelings" he stimulates: this is what low women may believe. But according to the degree he approaches the great style, being capable of great style. What this style has in common with great passion is that it refuses to please; that it forgets to persuade; that it commands; that it wants ... To master the chaos that one is; to force one's chaos to become form; to become necessity in form: to become logical, simple, unambiguous, (to become) mathematics; to become **law** –: this is the great aspiration here. One repels with it; nothing attracts love for such brutes anymore – a wilderness grows around them, a silence, a fear like of a great sacrilege ...

All forms of art know those who are ambitious of great style: why are they absent in music? Never has a musician created anything comparable to what the architect of the Palazzo Pitti has created?.. Here lies a

problem. Does music, perhaps, belong to a culture where the empire of all sorts of brutes has already ended? Finally, wouldn't the term great style already contradict the soul of music, – the "woman" in our music? ...

I am touching a cardinal question here: where does all our music belong? The ages of classical taste do not know anything comparable to it: it was blooming when the world of renaissance was reaching dusk, when "freedom" had already left the mores and even the people's wishes: is it part of its nature to be counter-renaissance? like, for example, the baroque style is art of decadence.? Is it the baroque style's sister, as it is in any case its contemporary? Isn't music, modern music already *decadence?* ...

Music is counter-renaissance in art: it is also *decadence* as social expression

I have already pointed at this question before: isn't our music a bit of counter-renaissance in art? isn't it the closest relative of the baroque style? Hasn't it developed in contradiction to all classical taste, so that it would be forbidden all classical ambition? ...

An answer to this first-rate question of value judgment would not have to be ambiguous if the fact that music as romanticism finds its highest maturity and profusion – once again as a counter-movement to the classical – had been estimated correctly...

Mozart – a tender and loving soul, but totally 18th century, even in his earnestness ... Beethoven the first great romantic, in the French sense of romanticism, as Wagner is the last great romantic... both instinctive opponents of classical taste, the austere style, – not to speak of the "great" one here ... both –

If the innermost nature of being is will to power, if lust is all increase of power , listlessness all feeling of not being able to resist and master anything: aren't we allowed to

look at lust and listlessness as cardinal facts then? Is will possible without these two oscillations of yes and no? But who feels lust? ... But who wants power? ... Absurd question: if the subject itself is will to power, hence the feeling of lust and listlessness. Nevertheless: one is in need of opposites, hence resistance, relative to the **overlapping units** ... located –

When A affects B, A is not located before it is separated from B

Counter-Movement: Religion
The Two Types:
Dionysus and the Crucified

to note: the typical **religious** man – a form of *decadence*?

The great innovators are each and all pathological and epileptic

: But don't we leave out a type of religious man, the heathen? Isn't heathen cult a form of thanksgiving and affirmation of life? Shouldn't its highest representative be an apology and apotheosis of life?

Type of a full and ecstatically overflowing mind... **redeeming** type incorporating the contradictions and problems of being?

–This is where I place the **Dionysus** of the Greeks: the religious affirmation of life, complete life, not the denied and halved one

Typical: that the sexual act evokes depth, mystery and awe

Dionysus against the "crucified": here you have the contrast: It is not a difference in respect to martyrdom, – only the same has a different meaning. Life itself, its eternal fertility and recurrence causes suffering, destruction, the will to annihilation...

in the other case suffering, the "crucified as the innocent" as an objection against this life, as a formula of its condemnation.

You guess: the problem is the one of the sense of suffering: whether it is a Christian sense or a tragic sense ... In the former case it shall be the way to a blessed form of being, in the latter, being is considered blessed enough, to justify an enormity of suffering

The tragic man even accepts the bitterest suffering: he is strong, full, idolizing enough for it.

The Christian denies even the luckiest fate on earth: he is weak, poor, disinherited enough to suffer from life in all forms...

"the god on the cross" is a curse to life, a hint to save oneself from it

cut-up Dionysus is a **promise** of life: it will be reborn forever and come home out of destruction

Religion as decadence
Buddha against the "Crucified"

Within the nihilistic movement you may still sharply distinguish between the **Christian** and the **Buddhist** school

: The Buddhist school expresses a beautiful evening, a perfect sweetness and mildness, it is gratefulness for everything that lies behind, included; bitterness, disappointment, *rancune* are absent

: Finally, high intellectual love, the refinement of physiological contradiction is behind it, it rests from that too: yet it has its intellectual glory and sunset glow from it. (– origin from the highest castes. –

: The Christian movement is a degenerate movement of all kinds of waste and refuse elements: it does not express the decline of a race, right from the start it is an aggregation of morbid matter huddled together and seeking its like ... hence it is not national, not determined by race: it addresses the disinherited from everywhere

It is based on *rancune* against everything good and

dominant, it needs a symbol which depicts the curse on the good and dominant...

It opposes all **intellectual** movement, all philosophy: it sides with the idiots and utters a curse against the intellect. *Rancune* against the gifted, the erudite, the intellectually independent: it recognizes the **good and lordly** in them

The real **philosophers of the Greek** are the ones before Socrates: with Socrates something changes

They are all noble individuals, aloof from the common people and their customs, travelled, earnest to the point of gloominess, with a slow eye, acquainted with public affairs and diplomacy. They anticipate all the wise men's great conceptions of things: they show them themselves, they bring themselves into the system.

Nothing offers a higher idea of Greek intellect than this sudden profusion of types, than this involuntary comprehensiveness in the formation of the great possibilities of <the> philosophic ideal.

I only see one original character in the following: a late-coming but necessarily the last ... the nihilist Pyrrho, ... he has the instinct against all that is on top in the meantime, the Socratic, Plato

Pyrrho refers to Democritus via Protagoras ... the artist's optimism of Heraclitus, –

the counter-movement: art
The ecstasy, actually analogous to a surplus of strength:

Strongest in the mating season of the sexes: new organs, new skills, colours, forms ...

The "beautification" is a consequence of increased strength

Beautification as the necessary consequence of the increase of strength

Beautification as the expression of a **victorious**

will, of increased co-ordination, a harmonizing of all strong desires, an infallibly perpendicular emphasis

The logical and geometrical simplification is a consequence of the increase of strength: reversely the perception of such a simplification increases the feeling of strength ...

The top of the development; the great style

Ugliness means *decadence* of a type, contradiction and a lack of coordination of the inner desires

Means the decline of an organising power, of "will", physiologically speaking ...

The state of lust, which is called ecstasy, is exactly a feeling of strong power...

Perception of space and time is changed, enormous distances are overlooked and, at the same time, become perceivable so to speak

The extension of the gaze over larger amounts and greater distances

The refinement of the organ for the perception of many minuscule and ephemeral things

Divination, the power of understanding on the faintest help, on every suggestion, the "intelligent" sensibility ...

Strength as a feeling of control in the muscles, as elasticity and lust for movement, as a dance, lightness and presto

Strength as the lust for the proof of strength, as a feat of daring, an adventure, fearlessness, indifferent nature ...

All these high moments of life stimulate each other; the ones' world of images and ideas suffices, as a suggestion, for the others ...In such a manner states which would have good reasons to remain alien to each other are finally interwoven into each other. For example

Religious ecstasy and sexual arousal (two deep emotions, coordinated in an almost stupefying way. What

pleases all pious women, young and old? Answer: a saint with beautiful legs, still young, still an idiot ...)

Cruelty in the tragedy and pity (– also regularly coordinated ...

Spring, dance, music, all contest of the sexes – and also that Faustian "infinity in the bosom" ...

The artists, if they are good for something, are designed as strong (physically too), excessive, strong-arm animals, sensual; without a certain overheating of the sexual system no Raphael is thinkable ... Making music is also a form of making children; chastity is only the economy of an artist: – and, anyway, in the artists' case too, creativity ends with potency ...

Artists should not see anything as it is but fuller, but simpler, but stronger: for that matter they must harbour some sort of eternal youth and spring, some sort of habitual ecstasy inside themselves.

Beyle and Flaubert, two unobjectionable cases in such questions, have indeed recommended chastity to artists in the interest of their craft: I could have also mentioned Renan, who suggests the same, in this respect,. Renan is a man of the cloth ...

Counter-Movement
Art

All art operates as a suggestion on the muscles and senses at work in the naïve artistic individual: it always speaks to artists only, –

It talks to this species about the delicate excitability of the body. the term "layman" is a wrong choice. The deaf is no species of the ones who hear properly.

All art has a **tonic** effect, increases strength, inflames lust (i.e. the feeling of strength), stimulates all the delicate memories of ecstasy, – there is a special memory that comes down into such states of mind: a

remote and ephemeral world of sensations returns here...

The ugly i.e. the contradiction to art, what is **excluded** by art, its negation – each time when decline, impoverishment of life, powerlessness, disintegration, decay are only remotely suggested, the aesthetic individual reacts with his opposition

The ugly has a **depressing** effect, it is the expression of depression. It **takes** strength, it impoverishes, it oppresses ...

The ugly **suggests** ugly things; you can try out with your states of health how differently ill-health also increases the ability of fantasising the ugly. The choice of things, interests, questions changes: there is also in logic a state closely related to the ugly – heaviness, dullness ..

Mechanically. the gravitational pull is absent; the ugly limps, the ugly stumbles:– opposite to the divine light-footedness of the dancing ...

The aesthetic state has an abundance of **means of communication**, likewise an extreme **receptiveness** for stimulations and signs. It is the climax of communication and transferability between living beings, – it is the origin of languages.

Here languages have their origin: the languages of sound, as well as the languages of gesture and gaze. The beginning is always the fuller phenomenon: our abilities as civilized men are subtracted from fuller abilities. But even today one listens with the muscles, one even reads with the muscles.

All mature art is based on a plenty of conventions: inasmuch as it is language. Convention is a prerequisite of great art, **not** its prevention ...

All elevation of life increases the expressiveness as well as the comprehension of man. **Growing into other people's souls** is nothing moral originally but a physiological sensitiveness of suggestion: "sympathy" or what is called "altruism" are merely variations of that

psycho-motoric rapport (*induction psycho-motrice* according to Ch. Féré) which is classed with intellectuality. We never communicate ideas, we communicate movements, mimic signs which we **reread** to find the ideas ...

Love

Does one want the most astonishing proof for how far ecstasy's power of transfiguration goes? "Love is this proof, the thing called love, in all languages and all muteness of the world. Here ecstasy copes with reality in a way that cause is erased in the consciousness of the loving person and something else seems to replace it – a trembling and flashing-up of all magic mirrors of Circe ... There is no difference between man and animal; even less, mind, goodness, honesty ...One is subtly fooled if one is subtle, one is crudely fooled if one is crude: but love, even the love of God, the love of saints of "redeemed souls" remains one thing at its root: (as) a fever that has good reasons to transfigure, an ecstasy that does good, to lie about oneself ... anyway, one lies well if one loves, to oneself and about oneself: one seems transfigured, stronger, richer, more perfect, one **is** more perfect ... Here we find **art** as an organic function: we find it embedded in the most angelic instinct of life: we find it as the greatest stimulant of life, – hence art even sublimely useful in the respect that it lies ...But we would err if we stopped at its capacity to lie: it does more than merely imagine, it even shifts the values. and not only that it shifts the feeling of values... the loving person is more valuable, is stronger. In the animals this state brings out new substances, pigments, colours and forms: above all, new movements, new rhythms, new mating sounds and seductions. It is not different with man. His entire system is richer than ever, more powerful, more complete than in a non-loving man. The lover becomes a

squanderer: he is rich enough for it. Now he becomes daring, an adventurer, becomes an ass of magnanimity and innocence; he believes in God again, he believes in virtue because he believes in love: and, on the other hand, this idiot grows wings of bliss and new talents and even the door to art opens for him. Let us subtract the suggestive power of this intestinal fever from poetry of words and sound: what remains of poetry and music? ... perhaps *l'art pour l'art*: the resourceful croaking of neutralized frogs despairing in their swamp ... love created all the **rest** ...

A philosopher is wise, if he is "unpractical": he makes us believe in his authenticity, simplicity, innocence in the intercourse with ideas, – unpractical means "objective" in his case. Schopenhauer was wise when had someone photograph him in an incorrectly buttoned waistcoat: with this he implied: "I do not belong to this world: what does a philosopher care about parallel seams and buttons! ... I am too objective for this! ..."

It is not enough to prove that one is **unpractical**: doing this, most philosophers think they have done enough to raise objectivity and purity of reason beyond all suspicion.

1. All philosophers' allegedly pure epistemological drive is commanded by their moral "truths", is only seemingly independent ...

2. the "moral truths" " you shall act like this" are mere forms of consciousness of an instinct getting tired: "one acts such and such in our world." The "ideal" is supposed to reconstruct an instinct, strengthen it: it flatters man to be obedient when he is only an automaton.

One need not look for phenomenalism in the wrong place: nothing is more phenomenal (or more explicitly)

118 + Friedrich Nietzsche

nothing is so much **delusion** like this inner world which we observe with the famous "inner sense."

We have believed in the will as cause, up to the extent that we have at all attributed a cause to the event according to our personal experience (i.e. intention as the cause of an event.

We believe that idea and idea in their succession have some causal linkage: especially the logician, who actually speaks of cases that never happen in reality, has got used to the prejudice that ideas **cause** ideas, – he calls this – thinking …

We believe – and even our physiologists still believe – that lust and pain are the cause of reactions, that it is the purpose of lust and pain to give rise to reactions. Lust and the avoidance of listlessness have indeed been postulated as the motives of all action for thousands of years. After some consideration we might admit that everything would happen like this, according to exactly this chain of causes and effects, if the states of "lust and pain" were absent: and one errs if one simply claims that they cause anything: they are **concomitant phenomena** with a completely other finality than the one to occasion reactions; they are already effects within the initiated process of reaction….

In summation: everything that becomes conscious is a final phenomenon, an end – and does not cause anything – all successive in consciousness is completely atomistic. And we have tried to understand the world with the **reverse** conception, – as if nothing had an effect or were real except thinking, feeling, wanting …

Philosopher

Pyrrho, the most lenient and most patient man that has ever lived among the Greeks, a Buddhist though a Greek, a Buddha himself, was only once driven beside himself, by whom? by his sister, with whom he lived together: she

was a midwife. Since then philosophers are most afraid of the sister– the sister! Sister! it sounds so terrible! – and of the midwife! ... (origin of the celibate)

The Counter-Movements: Art
The exceptional states occasion the artist: all that are closely related to and deeply rooted in pathological phenomena: so that it seems impossible to be an artist without being ill.

The physiological states, virtually developed into some kind of persona in the artist, that are to any extent inherent in mankind:

1. The **ecstasy**: the increased feeling of power; the inner urge to make a reflection of ones own opulence and perfection out of things –

2. The **extreme sharpness** of certain senses: so that they comprehend – and create – a completely different sign language ... – the same as the one seemingly connected to some nervous diseases – extreme agility that turns into extreme communicativeness ... the need to say everything signs can express ... a need to virtually get rid of oneself via signs and gestures; the ability to speak of oneself through a hundred means of language ... an **explosive state** – first, you have to think of this state as a compulsion and an urge to get rid of the exuberance of the inner tension with all kinds of muscle work and agility: then as an involuntary **coordination of this movement** to the inner events (images, ideas, desires) – as some sort of automatism of the entire muscular system caused by the impulse of strong stimulations working from inside – incapability to **stop** the reaction; the control apparatus virtually **unhinged**. All inner movement (feeling, thought, affect) goes hand in hand with vascular changes, hence changes of colour, temperature, secretion; the **suggestive power of music**, its "suggestion mentale";

3. The compulsion to imitate: extreme irritability, where a given model communicates contagiously , – a state is already estimated and depicted because of signs ... an image, surfacing inside already functions as a movement of the limbs ... a certain **unhinging of the will** ... (Schopenhauer!!!!)

Some sort of deafness, blindness towards the outer world, – the realm of the **licensed** stimulations is sharply circumscribed –

This distinguishes the artist from the layman (the receptive for art): the latter has his climax of stimulation in reception: the former in donation – in such a manner that an antagonism of these two talents is not only natural but desirable.

Each of these states has a reverse optical impression, – to demand from the artist to practise the optical impression of the listener (critic, –),means to demand that he **impoverish(es)** his specific **strength** ... It is the same as with the difference of the sexes here: one should not demand from the artist, who gives , that he turns into a woman – that he "conceives" it...

In this respect our aesthetic has been a woman's aesthetic so far, in so far as only the receptive for art have formulated their experiences with regard to "what is beautiful?" What has been absent in all philosophy until today, is the artist ... This is, as I have suggested above, a necessary mistake; for the artist who would begin to understand would make a mistake in this respect – he should not look back, he should not look at anything at all, he has to give – It honours an artist to be incapable of critique ...otherwise he is neither here nor there, he is "modern" ...

The New World-Conception

1) The world exists; it is nothing that comes into

existence, nothing that passes away. Or rather: it comes into existence, it passes away but it has never begun to come into existence and never stopped to pass away – it subsists on both ...It lives on itself: its excrements are its food ...

2) The hypothesis of a **created** world shall not even grieve us for a moment. The term "create" is completely indefinable, not applicable; just a word, from the rudimentary times of superstition; you do not explain anything with a word. The last attempt to conceptualise a world that **begins** has been made recently with the help of a logical procedure – most of the times, as one might guess, with a theological ulterior motive.

The Eternal Return. Philosophy

3) Lately one has been eager to find a contradiction in the notion of a backward temporal infinity of the world: it has been found, of course, at the price of the tail wagging the dog. Nothing can prevent me from saying, counting backwards form this moment onwards, "here I will never come to an end": as I can count forwards from the same moment onwards, into infinity. Only if I wanted to make the mistake – I will take good care not to make it – to equate this correct notion of a regressus in infinitum with the **impossible notion** of an infinite progressus up to the present moment, if I regard **direction** (forward or backward) as logically indifferent, I would wag the dog : I leave this to you, Mister Dühring!
...

4) I came across this idea in earlier thinkers: each time it was determined by different ulterior motives (most of the times theological ones in favour of the creator spiritus) If the world could at all freeze, dry up, wither, become **nothing**, or if it could reach a state of equilibrium; or if it had at all any objective that included

duration, unchangeability, the once-for-all (briefly, metaphysically speaking: if the coming into existence **could** end in being or nothingness) this state should have been reached. But it has not been reached: which means ... This is the only certainty we hold in our hands to serve as a corrective against the profusion of possible hypotheses of the world. E.g. if the mechanism cannot escape the consequence of a final state, which Thompson has drawn in its respect, the mechanism is **refuted.**

Philosophy

If the world may be thought of as a definite quantity of power and as a definite number of centres of power – and every other conception remains vague, ergo **useless** – it follows that it has to undergo a calculable number of combinations in the great game of dice of its existence. Within an infinite time span every possible combination would be reached some time or other; even more, it would be reached an infinite number of times. And, as between each "combination" and its next "return" all actually possible combinations should have come up and each of these combinations causes the entire sequence of combinations in the same row, a cycle of absolutely identical rows would be proven: the world as a cycle that has already repeated itself an infinite number of times and that plays its game in infinitum.

This conception is not without further consideration a mechanistic one: for if it were like that, it would not occasion an infinite return of identical cases but a final state. As the world has not reached it, this mechanism must be looked upon as a preliminary hypothesis.

Weakness of will: this is a possibly deluding simile. For there is no will, hence neither a strong nor a weak will. The multiplicity and disgregation of drives, the lack of

system inside them results in "weak will"; their coordination under the predominance of a singular one results in "strong will";– in the former case it is oscillation and a lack of emphasis; in the latter the precision and clarity of direction

Progress
VI
But don't let ourselves be deceived! Time runs forward, – we want to believe that everything contained in it runs forward too ... that evolution is a forward-development ... This is the appearance even the most cautious ones are tempted by: but the 19th century is no progress compared to the 16th: and the German intellect of 1888 is a retrogression compared to the intellect of 1788 ... "mankind" does not advance, it does not even exist ... Its overall view is the one of an immense experimental workshop where the one or other thing turns out well, dispersed over all times, and unspeakably much fails, where all order, logic, connection and commitment is absent... How could we fail to see that the rise of Christianity is a movement of *decadence* ... that the German Reformation is a recrudescence of Christian barbarism? ... that the Revolution has destroyed the instinct of organisation on a large scale, the possibility of a society? Man is no step forward to the animal: the cultural weakling is a freak compared to the Arab and the Corsican; the Chinese is a fine type, more enduring than the European ...

A Prologue
I have the luck and perhaps even the honour to have found the way again that leads to a yes and a no, after thousands of years of aberration and confusion.

I teach the no (to) all that makes you weak – that exhausts.

I teach the yes to all that makes you stronger, that stores strength, that ... pride –

Neither the one nor the other has been taught so far: virtue, self-sacrifice, empathy, even negation of life have been taught ... They are all values of the exhausted

Thinking for a long time about the physiology of exhaustion I was forced to ask myself how deeply the judgments of exhausted people have already penetrated the world of values.

My results were as surprising as possible, even for me, a man who has already visited the one or other alien world: I found all supreme value judgments, all that have mastered mankind, at least tamed mankind, tamed by the judgments of exhausted people.

I will need to teach that crime, celibate, disease are the consequences of exhaustion ...

I pulled out the destructive tendencies under the holiest names; God has been cited, which makes weak, teaches weakness, weakness infects ... I found out that the "good man" is an affirmative form of *decadence*.

The virtue Schopenhauer used to present as the supreme one, the only one and the fundament of all virtues: (I) realised that exactly this empathy is more dangerous than any vice. To thwart selection in the species, its purification from waste – this has been the virtue par excellence so far...

The race is spoilt – not by its vices but by its ignorance: it is spoilt because it did not understand exhaustion as exhaustion: the physiological confusions are the source of all evil (because) its instinct has been tempted by the exhausted to hide their best and lose emphasis ... To fall down – to negate life– this should be regarded as a rise, transfiguration, apotheosis

Virtue is our great misunderstanding.

Problem: how did the exhausted manage to make the laws and values?

Put differently: how did the Last come into power? Realize history! Why has the human animal's instinct been turned upside down? ...

I wish to precise the notion of "progress" and I am afraid I will have slap the modern ideas' face (– it is my consolation that they do not have faces, only **masks** ...

Sick limbs shall be amputated: first moral of society.

A correction of instincts: their separation from ignorance ...

I despise the ones who demand from society that it saves them from their detriment. This is by far not enough. Society is a body where no limb ought to be sick if it does not want to get into trouble: a sick limb has to be amputated: I am going to tell you the names of the types of society **that must be cut off**...

You must honour **dire fate**: dire fate that tells the weak: perish ...

It has been called **God** to resist dire fate, – to spoil mankind and make it foul ... one shall not use the name of God for the wrong reasons...

We have annulled almost all psychological notions the history of psychology – which means philosophy! – has depended on so far

We deny that there is a will (not to speak of "free will")

We deny consciousness, as a unity and capacity

We deny thinking (: for what thinks as well as what is thought is absent

We deny that there is a real causality between the ideas, as logic believes

My writing turns against all natural types of *decadence*: I have been thinking most comprehensively about the phenomena of nihilism

i.e. the born annihilator –

Forgive me! But this is all the old game of 1830. Wagner believed in love, like all romantics of this crazy and licentious decade. What has remained of it? This senseless idolization of love, and, beside that, of excess and even crime – how wrong this seems to us today! How worn out above all, how superfluous! We have become stricter, harder, more impatient with such vulgar psychology, which even was thought to be "idealistic", – we are even cynical in respect to this hypocrisy and romanticism of the "beautiful feeling" –

IX

If morals have been virtually stored in a long line of generations – hence refinement, circumspection, courage, fair-mindedness – the comprehensive power of these piled-up virtues even shines into the sphere where honesty is rarest, the **intellectual** sphere.

An uneasiness of the organism is expressed in all consciousness: something new shall be attempted, nothing is sufficiently appropriate for that; there is strain, tension, over-excitement – this **is** all formation of consciousness …Genius is located in the instinct; goodness too. One only acts perfectly if one acts instinctively. From a moral perspective too, all conscious thinking is merely tentative, most of the times the contrary of morals. Scientific honesty is always unhinged when the thinker begins to argue: try it out, weigh every word of the wisest when they talk about morals.

It can be proven that all conscious thinking has a much lower level of morality than thinking guided by the **instincts.**

Nothing is rarer among the philosophers than **intellectual honesty**: perhaps, they claim the contrary, maybe they believe it themselves. But their craft entails that they only allow certain truths; they know what they **have to** prove, in their eyes the fact that they agree on

these "truths" almost suffices to distinguish them as philosophers. But the belief in morals is by far no proof of morality: there are some cases – and the case of the philosophers belongs here, where such a **belief** is simply an **immorality**.

At all times the "beautiful feelings" have been taken as arguments, the " elevated bosom" as the bellows of the deity, conviction as a "criterion of truth", the needs of the opponent as a question mark to wisdom: this hypocrisy, counterfeiting runs through the entire history of philosophy. the respectable but rare sceptics subtracted, an instinct of intellectual honesty is nowhere to be seen. Finally Kant, in all innocence, tried to make this intellectual corruption scientific when he coined the notion of "practical reason": for that particular purpose he invented a reason in which case one needn't care about reason: i.e. when the need of the heart, when moral, when duty speaks

The ignominious attempt has been made to see types of the mentally deranged in Schopenhauer and Wagner: an a great deal more essential insight would have been won if one had defined the type of decadence represented by both more precisely.

The **two great tentatives** to overcome the 18th century:
Napoleon awakening the man, the soldier and the great fight for power – conceptualising Europe as a political union
Goethe imagining a European culture in the full heritage of the already **achieved** humanity.

We are suspicious of all those ecstatic and extreme states of mind where one thinks one "grasps the truth with one's hands" –

Prologue

This book only addresses a few people, – **those who have become free**, those who aren't forbidden anything anymore: step by step we have regained the right to everything forbidden.

To prove the achieved power and self-confidence stating that one has "unlearned to be afraid"; to be allowed to exchange the confidence in ones instincts for distrust and suspicion; that one loves and respects each other in ones sense – even in ones **nonsense** – a little bit buffoon, a little bit God; no obscurantist, no owl. no blind-worm ...

That nothing is true what was once considered to be true:

That the things we were kept from – unholy, forbidden, despicable, doomed as they were – all those flowers are growing on the mellow path of truth today

All traditional moral does not concern us anymore: there is no term in it that deserves respect. We have outlived it,– we aren't crude and naïve enough anymore to have to let ourselves be fooled that way...more polity formulated: we are too virtuous for this ...

And if truth in the old sense was only "truth" because the old morals said yes to it, was allowed to say yes to it: it follows that there is no truth of old that is left to us ... Morality is by no means our **criterion** of truth: we **refute** a claim proving that it depends on morals , is inspired by noble feelings.

The **lack of philology**: one constantly mistakes the explanation for the text – and what kind of "explanation"!

Even the bravest among us only rarely has the courage to stand for what he actually – knows ...

We kill what does not kill us, this makes us stronger. *Il faut tuer le Wagnerisme.*

Who cannot apply his will to things, at least applies **meaning**: i.e. he believes that there is already meaning inside them.

The great style comes up as a consequence of great passion. It refuses to please, it forgets to persuade. It commands. It wants.

What is good? All that boosts the feeling of power, the will to power, power itself in man.

What is bad? All that has its origin in weakness.

What is happiness? – The feeling that power has grown again, – that again an obstacle has been overcome.

Not contentment but more power; not peace but more war; not virtue but proficiency (virtue in renaissance style, virtù, moral-free virtue).

What is weak and ill-begotten, shall perish: supreme imperative of life. And you should not make a virtue of compassion.

What is more dangerous than any vice? Active compassion with all ill-begotten and weak, – Christianity
...

Spring – Summer 1888

We many or few who dare to live in a **de-moralized** world, we heathen according to our faith: we are probably the first who realize what heathen faith is: to have to imagine entities higher than man, but beyond Good and Evil; to have to estimate all higher being as being immoral, too. We believe in the Olympus – and not in the "crucified" ...

–and if my philosophy is hell, I am at least going to pave the way to it with good aphorisms.

Without music life would be a mistake.

Man is a small eccentric species of animal that has – fortunately – its time; life on Earth a moment, an incident, an exception without consequences, something that remains insignificant for the overall character of Earth; Earth itself, like all stars, a hiatus between two nothingnesses, an event without a plan, reason, will, self-confidence, the worst kind of the necessary, the **stupid** necessity ...Something inside us rebels against this view; the snake Vanity tries to persuade us "This must all be wrong: because it is outrageous ... Isn't it possible that all is just an illusion? And man, in spite of all this, in the sense of Kant, –

There are the morning-thinkers, there are the afternoon-thinkers, there are the night owls. Not to forget the noblest species: the ones of noon, the ones inside whom great Pan sleeps all the time. All light falls vertically here ...

How I recognize people equal to me. – Philosophy, as I have understood and lived so far, is the voluntary visit of

also the accursed and heinous sides of being. I have learnt to see everything that has been philosophised so far differently from the great experience I gathered on my long march through the ice and the desert: – the **hidden** history of philosophy, the psychology of its great names came to the light for me." How much truth does a mind **bear**, how much actually does a mind dare?" – this became the real criterion for me. Error is **cowardice** ... each accomplishment of knowledge is based on courage, rigour against oneself, purity in oneself ... An experimental philosophy such as the one I live, anticipates, as an experiment, the possibilities of fundamental nihilism: but that does not mean that the No, the negation, the will to the No is its last word. It rather wants to get through to the reverse – to a **dionysic Yes** to the world, like it is, without deduction, exception and selection – it wants the eternal cycle,– the same things, the same logic and illogic of knots. The supreme state a philosopher can reach: to stand for being dionysically– : *amor fati* is my formula for this ...

It involves perceiving the so far negated aspects of being not only as **necessary** but as desirable: and not only as desirable in respect to the so far accepted aspects (e.g. as their complements or prerequisites) but for their own sake, as the more powerful, more fertile and **truer** aspects of being where its will pronounces itself more clearly. To the same extent it involves evaluating the so far only accepted side of life; realizing where this evaluation comes from and how little it is binding for a dionysic evaluation of life: I drew my conclusions and realized what actually says Yes here (first, the instinct of the suffering; secondly, the instinct of the flock, and this third one, the **instinct of the majority** in contradiction to the exceptions–) Hence I guessed in what way a different stronger kind of man necessarily has to imagine the elevation and improvement of man into a different

direction: as **higher** beings beyond Good and Evil, beyond the values that cannot deny their origin in the sphere of suffering, the flock and the majority – I have been looking for first signs of this reverse formation of ideals in history (re-discovering and presenting the notions "heathen", classic", "noble" –)

The effect of Wagnerian art is profound, above all it is very heavy: what is the reason for this? To begin with, certainly not Wagner's music: one only endures this music if one has already been overwhelmed by something other and one has become virtually **unfree**. This other is Wagnerian pathos, to which he has only added his art, it is the immense persuasive power of this pathos, its holding breath, its unwillingness to let extreme emotion go, it is the frightening **length** of this pathos, which makes Wagner victorious, will make Wagner victorious, in a way that he will finally convince us of his music... Is one a genius with such pathos? Or, can one even be? If you understand the genius of an artist as the highest freedom under the law, divine lightness, thoughtlessness in the most difficult, Offenbach (Edm(on) Audran) deserves even more than Wagner to be called a "genius". Wagner is heavy, heavy-handed: nothing is more alien to him than the moments of most frolicsome perfection this buffoon Offenbach reaches almost five or six times in each of his buffooneries. – But maybe one may understand something else under genius.– A different question that is still left to be answered, too: if Wagner, in such pathos, is German? a German? ...

Wagner is heavy, very heavy, *ergo* no genius? ...

Aesthet(ica)
Fundamental Insight: What is Beautiful and Ugly?

Nothing is more relative, or let us say more **narrow-minded** than our feeling of beauty. Those who wanted to see it freed of man's lust for man, would immediately loose the ground under their feet. Man as a type admires himself in the beautiful: in extreme cases he worships himself. It belongs to the nature of a type that only ones own sight makes one happy, – that one only says yes to oneself. Man, however much he sees the world overwhelmed with beautiful things, he has always overwhelmed it with his own "beauty": i.e. he regards everything as beautiful that reminds him of the feeling of perfection, with which, as a human being, he stands between all things. Has he really **beautified** the world with it? ... And if finally, in the eyes of a higher judge of taste, man is perhaps not at all beautiful? ... I am not going to say unworthy but a little bit funny? ..

(2)
–Oh, Dionysus, divine, why are you pulling my ears? I am finding some kind of humour in your ears, Ariadne: why aren't they even longer? ...

(3.)
"Nothing is beautiful: only man is beautiful" All our aesthetics are based on this naivety: it shall be its first "truth".

If we immediately add the complementary "truth", it is not less naïve: that nothing is uglier than the **ill-begotten** man.

Where man suffers from ugliness, he suffers from the abortion of his type; and where he is remotely reminded of such an abortion he calls it "ugly". Man has overwhelmed the world with ugly things: i.e. always only with his own ugliness... Has he really **uglified** the world through this?

(4.)

All ugly weakens and depresses man: it reminds him of decay, danger, impotence. One can measure the impact of the ugly with the dynamometer. Where he is depressed, something ugly is at work. The feeling of power, the will to power – it grows with the beautiful and falls with the ugly.

(5.)

An enormous pile of material is heaped up in the instincts and the memory: we have thousands of signs the degenerate of the type. Where exhaustion, fatigue, heaviness, old age, or constraint, convulsion, decay, disintegration are only insinuated, our lowest evaluative judgment speaks immediately: **there man hates the ugly** ...

What he hates, is always the decline of his type. The entire philosophy of art is built on this hate.

(6.)

If my readers are sufficiently informed that also "the good one" represents a **form of exhaustion** in the great universal spectacle of life, they will honour the consequence of Christianity, which conceptualised the good as the **ugly**. Hence Christianity was right. –

For a philosopher it is unworthy say: the good and the beautiful are one: if he even adds "the true, too", he shall be clobbered. The truth is ugly: **we have art** so that we are not ruined by the truth.

(7.)

The relationship of art and the truth made me earnest very early: and even today I am standing in front of this conflict in some sort of holy terror. My first book (was) devoted to it; the Birth of Tragedy believes in art on the basis of a different belief: **that it is not possible to live with the truth**; that the "will to truth" is already a

symptom of corruption ...

I am going to present the peculiarly gloomy and unpleasant conception of that book. Compared to other pessimistic conceptions it has the advantage that it is **immoral**: – unlike those it is not inspired by virtue, the Circe of philosophers. –

Art in the "Birth of Tragedy"

Wagner is a **capital factor** in the history of the "European mind" and ´the "modern soul": like Heinrich Heine. Wagner and Heine: the two greatest swindlers Germany has given to Europe.

I disassociated myself from Wagner when he retreated to the German God the German Church and the German Empire: Others were attracted by exactly this.

In Germany where the vaporizing of the ideal does not represent any objection against the artist but almost his justification (– it is attributed to Schiller! ... and if you say Schiller and Goethe, you mean the former was the better idealist, the real one: this heroic poser!

Physiologically examined "Kritik der reinen Vernunft" is already a pre-form of cretinism: and Spinoza's system a phenomenology of consumption

For the spider the spider is the perfect being; for the metaphysician God is a metaphysician: i.e. he is spinning mad

Wilhelm von Humbold(t), the noble imbecile

It will be interesting for the friends of the philosopher Friedrich Nietzsche to hear that last winter the witty Dane Dr. Georg Brandes dedicated a longer cycle of lectures at the University of Copenhagen to this philosopher. The speaker, whose mastery in the presentation of complex ideas need not to be proven, succeeded in evoking lively interest in the new and daring way of thinking of the German philosopher in more than 300 people: hence the lectures culminated in splendid ovations to the honour of the speaker and his subject.

Wagner has never learnt to walk. He falls, he stumbles, he abuses the poor Pegasus with lashes with a whip. All false passion, all falls counterpoint Wagner is **incapable** of any style. –

 artificial, gluey, false, concoction, monster, paste(board)

The **modern** artist, physiologically closely related to hysteria, is marked by this pathology as a character too. The hysteric is false: he lies for the sake of lying, he is admirable in all dissimulative art – if his pathological vanity does not play him a nasty trick. This vanity is an incessant fever that has to be anaesthetized and does not shrink back from self-delusion, from any farce promising temporary relief. To be **incapable** of pride and to be in constant need for revenge of a deeply-rooted self-deprecation – this is almost a definition of this form of vanity. The absurd irritability of a system that makes a crisis of any experience and stages "the dramatic" in the most banal incidences of life makes him unpredictable: he is no subject anymore, he is a host of subjects, of which now this one, then that one jumps out in an impertinently self-confident manner. This is why he is great as an actor: all these poor will-less studied by the

doctors in their neighbourhood who amaze us with their virtuosity of mimicry, their transfiguration and their appropriation of almost every character **demanded.**

May – June 1888

[+++] book only considered as different forms of lying; with their help you **believe** in life.

"Life shall fill us with faith: the task, set like this, is monstrous. To solve it, man must be a liar by nature, he must be an **artist** more than anything else. And he is: metaphysics, religion, morals, science – all only manifestations of his will to art, to the lie, to the escape from the "truth", to the **negation** of the "truth". This ability itself, with the help of which he rapes reality trough the lie, this artistic ability of man par excellence – he has it in common with all that exists. He himself is a part of reality, truth, nature: why shouldn't he also be a part of the **genius of the lie**! ..

That the nature of being is **misread** – lowest and highest secret intention behind everything representing virtue, science, faith, art. Many things never to be seen, many things to be seen wrongly, many things to be seen: oh, how clever one is in certain states where one is farthest away from considering oneself clever! Love, enthusiasm, "God" – all finesses of the final self-delusion, all seduction to life, all belief in life! In the moments when man becomes duped, when he tricks himself, when he believes in life: oh, how it swells inside him! What bliss! What feeling of power! How much triumph of the artist in the feeling of power! ...

Man once again master of "material"– master of truth! ... And whenever man is happy, he is always the same in his joy, he is happy as an artist, he enjoys himself as power, he enjoys the lie as his power ...

2.
Art and nothing but art! It is the great enabler of life, the great temptress to life, the great stimulant of life.
Art as the only superior counterforce against all will to the

negation of life, as the anti-Christian, anti-Buddhist, anti-nihilistic par excellence.

Art as **the redemption of the one who sees**, – the one who sees the atrocious and problematic nature of being, wants to see it, the tragically realizing one.

Art as the **redemption of the one who acts**, the one who does not only see the atrocious and problematic nature of being but lives it, wants to live it, the tragically martial man, the hero.

Art as the **redemption of the suffering**, – as a way to states of mind where suffering is accepted, transfigured, apotheosised, where suffering is a form of the great ecstasy.

3.

You see that pessimism, or more explicitly nihilism, is considered as the truth in this book. But the truth is not considered as the supreme value, even less as supreme power. The will to appearance, to illusion, to deception, to coming into being and transformation (to objective deception) is considered as more profound, more original, more metaphysical than the will to truth, to reality, to being: – the latter is itself only a form of the will to illusion. Likewise lust is considered as more original than pain: pain as a consequence of the will to lust (the will to coming into being, growing, shaping, ergo to **creation**: but destruction is always implied in creation) A supreme state of affirmation of being is conceptualised, where also supreme pain cannot be subtracted: the tragically dionysic state.

4.

In this way the book is even anti-pessimistic: ergo in the sense that it teaches something that is stronger than pessimism, that is more "divine" than the truth As it seems, nobody would endorse a radical negation of life,

even more a genuine active negation than saying no to life, like the author of this book: yet he knows, – he has experienced it, perhaps, he has not experienced anything else – that art is more precious than "the truth."

In the preface, a quasi-invitation to a dialogue to Richard Wagner the profession of faith, the artist's gospel comes up: "art as the actual task of life, art as a **metaphysical pursuit**..."

That the young strong races of northern Europe have not rejected the Christian god does not honour their religious talent, not to speak of taste. They **should** have handled such a senile manifestation of decadence. Yet a curse has been laid upon them for not getting rid of it: they have incorporated disease, ambiguity, old age in all their instincts; – they **haven't created** any god since then! Almost 2000 years: and not one new god! But still, as if it were justified, like an ultimum and maximum of the god-creating force, the creator spiritus in man, this miserable god of European monotheism! this hybrid manifestation of decay out of nil, terminology and senility, where all instincts of decadence have been sanctioned! ...

5.

–And how many new gods are still possible! ... To me, inside whom the religious, i.e. **god-creating** instinct at times wants to come back to life: how differently, how diversely the divine has revealed itself to me each time! .. so many strange things have passed in front of me in those timeless moments falling down into life like from the moon, when one absolutely does not know how old one is and how young one will be ... I would not doubt that there were many kinds of gods. There is no lack of such gods who cannot be imagined without a certain degree of Halcyonism and recklessness...light-footedness even belongs to the notion of "God". Is it necessary to

explain that a god knows at all times how to behave beyond all reason and uprightness? by the way, beyond Good and Evil too? in Goethe's words – he has an unobstructed view. And, to address Zarathustra's grossly under-valued authority: Zarathustra even goes as far as to testify of himself "I would only believe in a God who knows how to **dance**" ...

Once again: how many new gods are still possible! – Zarathustra himself is, of course, only an old atheist. You have to understand him correctly! No doubt, Zarathustra says he would –; but Zarathustra won't ...

July – August 1888

The deeply wounded have the Olympic laughter; you only have what you need.

Summer 1888

you stiff sages
everything was a game to me

my wisdom became a flash
with a diamond sword it cut through all
darkness

they are so cold, these scholars!
that their meal should be struck by lightning!
that they learn to eat fire!

our hunt for the truth –
is it a hunt for happiness?

I am only a maker of words:
words matter!
I matter!

Fall 1888

Oh, what a blessing is a Jew among German cattle! ... This is something the anti-Semite gentlemen under-estimate. What actually is the difference between a Jew and an anti-Semite: the Jew knows that he lies whenever he lies: the anti-Semite does not know that he always lies –

September – October 1888

One shall never forgive the Germans to have deprived renaissance of its objective, of its victory,. – the victory over Christianity. The German Reformation is its dark curse ... And another three times this race of bad luck has interfered to impede the course of culture – German philosophy, the wars of liberation, the foundation of the empire in the end of the nineteenth century – all great calamities of culture!

I have never suffered from not being honoured,– I see it as an advantage. On the other hand, I have experienced so much distinction and honour in my life, from my early years that I –

October 1888

About the reason of life. – relative chastity, fundamental and wise caution in erotic matters even in ones thoughts can belong to the great reason of life even in abundant and whole characters. This sentence especially refers to the **artists**, it belongs to their best worldly wisdom. Totally unsuspicious voices made themselves heard in this sense. I mention Stendhal, Th. Gautier, Flaubert too. Perhaps, the artist in his mentality is necessarily a sensual man, on the whole excitable, in every sense open to stimulation, coming to meet the remotest suggestion of stimulation. Nevertheless, due to the sheer size of his task, his will to mastery, he is actually a moderate man, often even a chaste man. His dominant instinct demands this: it does not allow him to spend himself this or that way. It is the very same power that one spends in the conception of art and in the sexual act: there is only one kind of power. To be defeated **here**, to spend oneself **here** is revealing for an artist: it reveals the lack of instinct, of will as such, it can be a sign of decadence, – anyway, it devaluates his art to an incalculable degree. I am going to take the most unpleasant case, the Wagner case. – Wagner, under the spell of the unbelievably pathological sexuality that was the curse of his life, knew too well what an artist loses under its influence, that he loses his freedom, his **self-respect**. He is condemned to be an actor. His art itself becomes a permanent attempt to escape, a means to forget himself, to **anaesthetize** himself, – it changes and, finally, determines the nature of his art. Such an "unfree" is in need of a hashish world, of strange, strong fumes , all kinds of exoticism and symbolism of the ideal, only to get rid of his reality, – he is in need of Wagnerian music ... A certain catholicity of the ideal in all is almost the proof for an artist's self-deprecation, of "swamp": the case of Baudelaire in France, the case of

Edgar Allan Poe in America, the case of Wagner in Germany.– Do I have to add that Wagner owes his success to his sensuality? that his music lures the lowest instincts to him, Wagner? that this holy notion of ideal, of 3/8-Catholicism is another art of temptation? (– unknowing, innocent, Christian, it allows to let "the magic" affect oneself...) Who dares the word, the **real** word for the ardeurs of the Tristan – music?. I always put on gloves when I read the score of Tristan ... This more and more spreading Wagnerism is a lesser case of an epidemic of sensuality that "does not know"; I consider imperative every caution against Wagnerian music. –

At the risk of giving the anti-Semite gentlemen the "well-measured" push, I confess that the art of lying, the "unconscious reaching out of long, too long fingers, the **swallowing** of other people's property has been much more evident to me in every anti-Semite than in any Jew. An anti-Semite always steals, always lies – he can't help it ... Because he has [–] ... You should deplore the anti-Semites, you should collect money for them. –

On this perfect day, where all is ripening and not only the grape is turning yellow, a ray of light has just fallen on my life – I saw backwards, I saw beyond,– I have never seen so much and so many good things at once. Not in vain I have just buried the forty-fourth year I was allowed to do it: what was in it, is saved, – is immortal. The first book of the devaluation of values; the first 6 songs of Zarathustra; the Götzen-Dämmerung (Götterdämmerung), my attempt to philosophise with the hammer – all gifts of this year, even the last quarter of this year – how shouldn't I be grateful to my life!

And so I am telling myself the story of my life.

Who knows something about me, guesses that I have experienced more than any other man. This is even

witnessed in my books: which are, line by line, lived books out of my will to life, hence represent, as **creation** a genuine addition, a more of that life itself. A feeling that overcomes me often enough: like a German scholar has said about himself and his things in an admirably innocent manner: every day offers the one more than an entire life offers others! **Bad things** among other things–no doubt! But it is the highest distinction life can offer that it also confronts us with its fiercest antagonism ...

October – November 1888

8.

I do not owe any familiar views to the Greeks; for, compared to Plato I am a too thorough sceptic and I have never shared the admiration of the artist Plato which is common among scholars. It seems to me that he mixes all forms of style: he has faults similar to the cynics, who invented the Satura Menippea. If you consider Platonic dialogue, its atrociously self-complacent and puerile dialectic stimulating; you have never read good French authors. Finally, my suspicion of Plato goes very deep: I consider him so aberrational from all fundamental instincts of the Hellenic, so rat-Jewish, so pre-Christian in his ultimate intentions that I would rather use the hard phrase "higher swindle" for the entire phenomenon Plato than anything else. You had pay a high price for the fact that this Athenian was educated by the Egyptians (probably Jews in Egypt ...) In the great doom of Christianity Plato is one of those fatal ambiguities that made it possible for the nobler characters of antiquity to enter the bridge leading to the "cross"... At every time **Thukydides** was my repose, my preoccupation, my cure from Platonism. Thukydides and, perhaps, Machiavelli's principe are most congenial to me, with their absolute will not to deceive themselves and to see reason in reality, not in "reason", even less in "morals" ... Nothing cures from the deplorable euphemism that the classically educated German gets as a reward for his "earnestness" of intercourse with antiquity more thoroughly than Thukydides. One must read him line by line and see what he has not written as clearly as his words: there are only a few comparably **substantial** thinkers. He perfectly expresses the culture of the Sophists, i.e. **the culture of he realists**: this inappreciable movement in the middle of the moralist and idealistic swindle of the Socratic schools

breaking off everywhere. Greek philosophy already as the **decadence** of Greek instinct: Thukydides as the sum total of all strong, austere, hard matter-of-factness lying in the instinct of the ancient Hellenic. **Courage** differentiates characters such as Plato and Thukydides: Plato is a coward– hence he escapes into the ideal – Thukydides controls himself, hence he controls things.

December 1888 – Beginning of January 1889

I know my fate. Once the memory of something gigantic will be associated with my name, – of a crisis like there has never been on Earth, of the most profound collision of conscience, of a decision conjured up against everything that has ever been believed, demanded, hallowed. – And in all this nothing of a fanatic is inside me; who knows me regards me as a modest, perhaps a little bit malicious scholar who can be cheerful with everybody. I hope this book offers a different image than that of a prophet. I have written it to destroy every myth about me at its root–, it is something playful even in my earnestness, I love the smallest things as I love the greatest things and I cannot get rid of my happiness in the moments of horrible decisions, I have the widest soul a man has ever had. Fatal (and–) god or buffoon- this is the involuntary in me, this is me. – And in spite of this or rather not in spite of this, for all prophets have been liars so far – the truth speaks out of me. – but my truth is **horrible**: so far the **lie** has been called the truth …**transvaluation of all values** is my formula for an act of supreme stock-taking of mankind: my fate wants that I look down deeper, more bravely, more honestly into the questions of all times than man has ever had to discover before … I am not challenging what is living now, I am challenging several thousands of years. I contradict, nevertheless I am the opposite of a negative mind. Hope only begins with me again, I know the tasks from an altitude that has not been measured so far, – I am the wordsmith of God par excellence as much as I always have to be the man of dire fate. When a volcano becomes active, we have convulsions on Earth like there have never been before. The notion of politics has completely dissolved in a ghost war, all configurations of power are blown up, there will be wars like there have never been

before on Earth. –

One last word. From now on I will need numerous helping hands – immortal hands!, the **Transvaluation** shall be published in 2 languages. It will be a good idea to found associations everywhere that at the right time I have some millions of supporters at hand. I make a point of having the officers and the Jewish bankers at my disposition first: – both together represent the **will to power.**–

Last Consideration

If we could do without wars, all the better. I would know a better use for the twelve billions the armed peace costs Europe every year; there are other means to honour physiology than military hospitals ... So far so good, even very good: after the old god has been assassinated, I am ready **to rule the world ...**

lords of the Solar Church

Volume 1: Friedrich Nietzsche

Friedrich Nietzsche's exterminating text, THE ANTICHRIST is a literary assassination of Christianity by the "philosopher with a hammer" at the height of his power, vitriol and — some say — madness. Soon after completing THE ANTICHRIST, Nietzsche collapsed and never fully recovered, dying two years later. In THE ANTICHRIST, Nietzsche not only negates the Bible and its teachings, but reinforces his insistence on man's survival by attaining the Will To Power. Only by the Will To Power can man transcend the idea of God and himself become an übermensch, or "superman". A century later, with Christianity under renewed assault and, according to some, Lucifer rising to ascendence in the new millennium, Nietzsche's words still hammer home his ineluctable, devastating message: GOD IS DEAD.

This special edition includes FRAGMENTS FROM A SHATTERING MIND, previously untranslated texts from 1888–89 as Nietzsche teetered on the precipice of insanity. Comprising new views on nihilism, the Antichrist, sex, decadence and power, plus calls for warfare and last warnings, these terminal writings form the revelatory sub-text of a titanic intellect on course for apocalyptic meltdown.

Volume 2: Friedrich Nietzsche

APOCALYPTIC TEXTS FOR THE CRIMINALLY INSANE

HAMMER OF THE GODS presents Friedrich Nietzsche's most prophetic, futuristic and apocalyptic philosophies and traces them against the upheavals of the last century and the current post-millennial panic. This radical re-interpretation reveals Nietzsche as the only guide to the madness in our society which he himself prophesied over a century ago; Nietzsche as a philosopher against society, against both the state and the herd; Nietzsche as philosopher with a hammer.

ECSTASY• WAR• DEICIDE
NIHILISM• CHANCE• REVENGE
ANTI-CHRIST• ÜBERMENSCH
AMNESIA• CHAOS• MASKS
SICKNESS• PAIN• SUICIDE
SOCIOPATHY• WILL TO POWER
ETERNAL RETURN• NEGATION

www.tearscorp.com

Lords of the Solar Church

Volume 3: Aleister Crowley

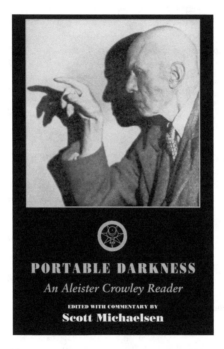

Infamous for scandalizing society on both sides of the Atlantic, Aleister Crowley (1875–1947) was a brilliant man whose position as the major intellectual figure on the occult has often been eclipsed by his own notoriety. While many of the details of Crowley's flamboyant life have been well documented, PORTABLE DARKNESS is the first book to tackle the formidable task of collecting the best of his voluminous lifework. In bringing together Crowley's best writings, editor Scott Michaelsen makes Crowleyan philosophy both accessible and intelligible. As an intellectual and mystic, Crowley devoted his life to the study of Qabalah, gematria, numerology, astrology, myth, glyphs, yoga, and linguistics. His intense, methodical exploration of so immense and arcane a range of knowledge has yielded, not surprisingly, a hugely challenging body of literature. In PORTABLE DARKNESS, Michaelsen has sifted through this vast, often abstruse oeuvre in search of those works which best display and illuminate the razor-sharp insight for which Crowley has become known. The selections in PORTABLE DARKNESS are organized thematically according to Crowley's favourite subjects, most notably the power of language, yoga, sex, and Magick. As accompanied by Michaelsen's cogent essays, these texts represent the essential Aleister Crowley, guiding novice and adept alike through the complexities of his notoriously impenetrable writings. Enlightening and revelatory, PORTABLE DARKNESS is an indispensable lexicon for all those with an interest in the occult.

With forewords by Robert Anton Wilson and Genesis P-Orridge, and a 12-page photo section.

www.tearscorp.com

𝔖𝔬𝔩𝔞𝔯 𝔟𝔬𝔬𝔨𝔰

PUBLISHING IN THE BRILLIANCE OF THE SUN

"Around us and in our hearts, the immense intoxication of the old European sun swaying between wine-coloured clouds... That sun struck our faces with its great torch of incandescent purple, then flared out, vomiting itself to infinity. Whirlwinds of aggressive dust; a blinding mixture of sulphur, potash, and silicates through the windows of the Ideal!... Fusion of a new solar orb that soon we shall see shine forth!"

—F.T. Marinetti, *Let's Murder the Moonlight*, 1909

"I want to have my throat slashed while violating the girl to whom I will have been able to say: you are the night."

—Georges Bataille, *The Solar Anus*, 1927

If one thing infuriated the Surrealists more than Salvador Dali's obsession with shit, it was his fascination with Hitler – in particular, the Führer's "milky white buttocks". But if Hitler was indeed a moonchild, the product of venom and venality, his analogue Benito Mussolini gavotted beneath the same Roman sun that once gilded the cheeks of Caligula as he crucified the Christian scum, the black sun worshipped by the boychild Heliogabalus in subterranean chambers of blood.

The Marquis de Sade, insuperable in the annals of sodomy, produced by a juxtaposition of excrement and roses the means to deify the naked beast that howls mournfully in the void of violence; whereas Blaise Cendrars, a founder of modernism, was yet haunted by primordial visions of crabs shaped like an ossified anus. Marinetti, leader of an order of assassins with directives to flay the night, proclaimed War as the art of the future, Europe as a canvas daubed with human death, a paroxysm of screaming vesuvial skulls.

Visionaries of the sun. A pentagram of black fire whose points extend from Artaud's Theatre of Cruelty to Bataille's acephalic rites, from Crowley's Cefalu to de Sade's Selligny and back to the divine carnage of Caligula's Rome. Pornography, black magic, lycanthropy.

God, how the corpse's blood is sad in the depth of sound: a vortex of manias sutured to the ancient eye, proclamations of murder and insanity, human sacrifice, deicide, dreams. Bones in the labyrinth that glisten with obscene clamour, even unto dust. An anal hex that rots unrequited, in paralyzing morbidity, glutted with blood and shit, a monument to the terminal velocity of the mind.

In the brilliance of the sun, new anatomies erupt from abattoirs and prisons, from mechanisms of atrocity, from backstreet latrines, and from mouths deliriously scarred by flowers.

In the brilliance of the sun, the scorpion cures the scorpion.

"The sun, situated at the bottom of the sky like a cadaver at the bottom of a pit, answers this inhuman cry with the spectral attraction of decomposition. Immense nature breaks its chains and collapses into the limitless void. A severed penis, soft and bloody, is substituted for the habitual order of things. In its folds, where painful jaws still bite, pus, spittle, and larvae accumulate, deposited by enormous flies: faecal like the eye painted at the bottom of a vase, this Sun, now borrowing its brilliance from death, has buried existence in the stench of the night."

—Georges Bataille, *The Pineal Eye*, 1929